IMAGES
of America

SHENANDOAH
APPLE BLOSSOM
FESTIVAL

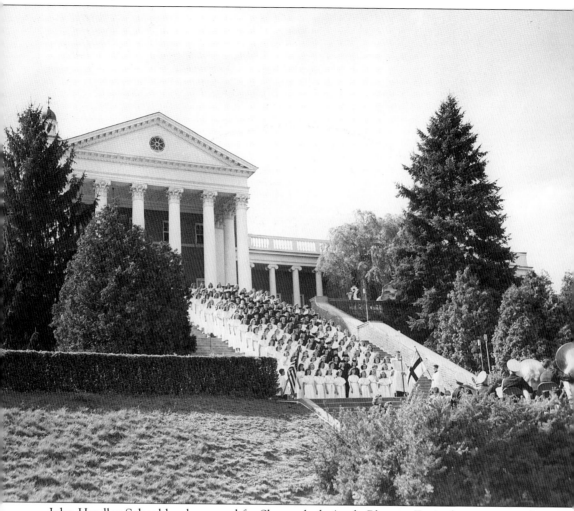

John Handley School has been used for Shenandoah Apple Blossom Festival events since the first parade ended there and Queen Shenandoah I was crowned in 1924. Some students and members of the Handley band are shown performing on the steps in this Virginia State Chamber of Commerce photograph. (Unidentified photographer; courtesy of the Handley Library Archives Collection.)

IMAGES
of America

SHENANDOAH
APPLE BLOSSOM
FESTIVAL

Helen Lee Fletcher

Copyright © 1999 by Helen Lee Fletcher.
ISBN 0-7385-0208-1

Published by Arcadia Publishing
Charleston SC, Chicago IL, Portsmouth NH, San Francisco CA

Printed in the United States of America

Library of Congress Catalog Card Number: Applied for.

For all general information contact Arcadia Publishing at:
Telephone 843-853-2070
Fax 843-853-0044
E-mail sales@arcadiapublishing.com
For customer service and orders:
Toll-Free 1-888-313-2665

Visit us on the Internet at www.arcadiapublishing.com

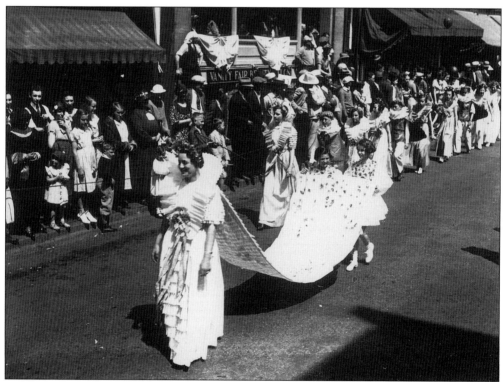

A Shenandoah Apple Blossom Queen and her court parade on Loudoun Street during an early festival. Every effort has been made to correctly identify participants and events of the festival in this book. In some cases, such as this photograph, relevant information was not available to the author. (Photograph by C. Fred Barr; courtesy of Bill Madigan.)

CONTENTS

ACKNOWLEDGMENTS

Acknowledgments for this work must begin with thanks to the thousands of volunteers who have nurtured the Shenandoah Apple Blossom Festival. No matter how many dignitaries and celebrities have participated during its 72-year history, fundamentally the festival represents community spirit. Many of the people who contributed time and talent in the first 50 years are mentioned by Mary Ann Clowser in her book *My Apple Blossom Times*. Her work and that of Katherine Glass Greene and Joanna Evans, archivist at the Handley High School, contributed to my knowledge of the festival. Rebecca Ebert, her staff, and volunteers at the Handley Regional Library Archives in Winchester have made this project possible with their cooperation and encouragement. The archives is a community resource of inestimable value, and all profits from the sale of this book will go to that facility to help continue the service now provided. Photographs from the archives include those of Mark L. Ainsworth, who was employed by the festival from 1974 to 1981. Frank Scheder and his crew at Valley Photo did a superb job printing glass and regular negatives. Philip Preffitt and Terry and Shirley Long Marshall helped enormously by identifying many of the festival participants. The encouragement of my daughter, Diane, and longtime companion Don is lovingly acknowledged.

More than half of the photographs used in this book are from the collection of Bill Madigan, who generously loaned the Apple Blossom negatives of C. Fred Barr. Mr. Madigan acquired the negatives from the photographer's widow when she closed Barr's Studio. Mr. Barr was born in Winchester in 1870 and received his education at local schools. After graduation, Barr became associated with a local photographic business that he later purchased. For the next 57 years, he operated one of the notable studios in the valley. Mrs. Barr continued to operate the studio after Barr's death in 1945. Photographs after that date are credited to Barr's Studio since it is not possible to identify individual photographers who worked there. Fred Barr's obituary described him as a man of the highest integrity with a keen sense of humor. As can be seen in this book, he also had a keen sense of what makes a great

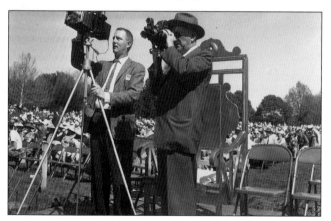

Photographers set-up at the Handley oval to record some of the 1959 Apple Blossom Festival activities. (Photograph by Barr's Studio; courtesy of Bill Madigan.)

INTRODUCTION

. . . the Apple Blossom Festival has been conceived and arranged to bring visitors from far and wide to Winchester and Frederick County that they might see the grandeur of our land at the time of its greatest beauty—apple blossom time.

—Harry F. Byrd

This annual festival will come to be the biggest thing in the business life of Winchester.

—W.A. "Dad" Ryan

Early in 1924, a group of Winchester citizens traveled south to Harrisonburg to explore ways to promote the Shenandoah Valley in general and the apple industry in particular. They attended a meeting of civic leaders from valley counties called by Mr. Frank L. Sublett, who was elected president of Shenandoah Valley, Inc. Among the ideas discussed was that a public activity be staged around the blooming of the apple trees. Upon returning to Winchester, Mayor William Wood Glass presided over a meeting of civic and fraternal organization members, and the idea to promote a festival was generally adopted. On April 21, 1924, W.A. "Dad" Ryan, general manager of the local gas company, was selected as director. Within two weeks, on May 3, the first Shenandoah Apple Blossom Festival was underway. In the official program, Mayor Glass gave credit to Mr. Sublett, "for the suggestion which has ripened into this festival." Although Ryan protested that he had lived in Winchester only two years and was not employed in an apple-related industry, he served as director general for the first three festivals and set a high standard for following festivals.

Community participation began in advance of the one-day event when a group of citizens invited President Herbert Hoover and his cabinet to come to the first Shenandoah Apple Blossom Festival. On May 1, 1924, the group left Winchester around 5 a.m. and arrived at the White House at 10 a.m. Newspapers of the day featured a photograph of the delegation on the lawn with the President after they presented him with White House vinegar, a box of apples, and, of course, apple blossoms. It seemed to members of the delegation that the President was interested in coming to the event, but they were informed later that he would be unable to attend. It was 40 years before a president of the United States attended the festival. In 1964, President Lyndon Johnson crowned his daughter, Luci, as Queen Shenandoah XXXVII. Over the years, additional events have been added and the festival now lasts several days, but the basics of proclaiming a Queen Shenandoah and holding a large parade are still the centerpieces of the celebration. As of 1999, the festival has been staged 72 times. It was not held between 1942 and 1945 during World War II. This book brings you the first 50 years of coronations, parades, and pageants, as seen through the eyes of talented photographers.

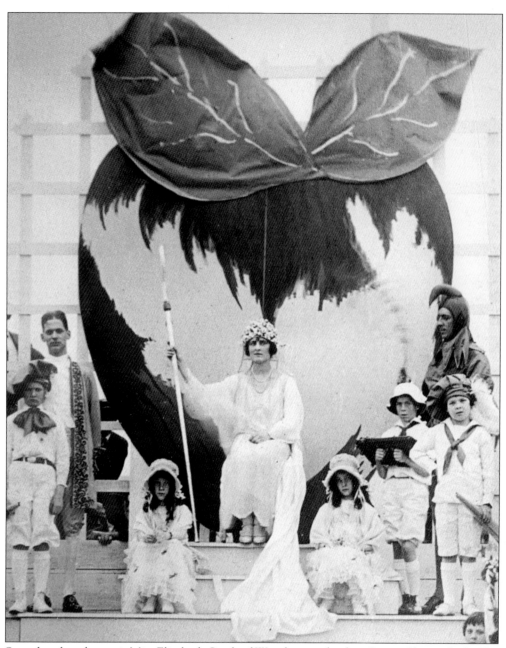

Seated on her throne is Miss Elizabeth Steck of Winchester, the first Queen Shenandoah. Her crown of artificial flowers was made by Margaret L. Hodgson. Artificial flowers were used after the real blossoms when the original crown wilted. In front of the queen are the Cooper sisters, Ethel and Retha. Harry F. Byrd Jr. is the lad in front of Prince of Apple Blossoms Richard L. Gray, on the left. Lewis H. Hyde is on the right, holding a pillow, and J. Kenneth Robinson is in front of Court Jester James Ross Dushane. (Photograph by C. Fred Barr; courtesy of Bill Madigan.)

One

WELL BEGUN

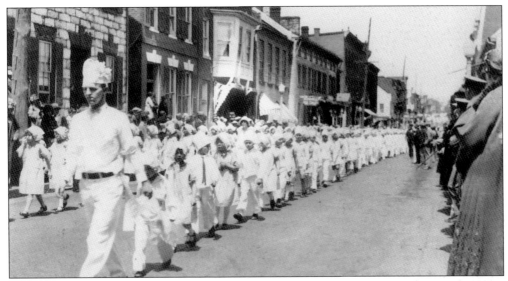

The first Apple Blossom parade started a few minutes before 2 p.m. on Saturday, May 3, 1924, when school children of Winchester marched in advance of a mile-long line of decorated cars, floats, bands, marching units, and local fire companies through the streets of town. Leading the parade on horseback was Grand Marshall W. Spottswood White. The parade moved to the Handley School grounds, where Richard L. Gray crowned the queen, Miss Elizabeth Steck. After the coronation was an address by Assistant Secretary of War John W. Weeks, interpretative dances, and fireworks. By the time of the afternoon events and the beginning of the first "Grand Feature Parade," the children had already had a very busy day. The morning program called for a parade led by school officials at the fairgrounds on the northwest corner of town. After the salute to the flag and a welcome by Mayor Glass, the children and spectators enjoyed a series of "stunts," as they were called in the official program. Included was crowning of the May Queen, winding of a Maypole, and health exercises, events held in previous years during spring frolics. An unidentified photographer captured the youngest of Winchester children parading on Loudoun Street in this c. 1924 photograph. (Courtesy of the Handley Archives Collection.)

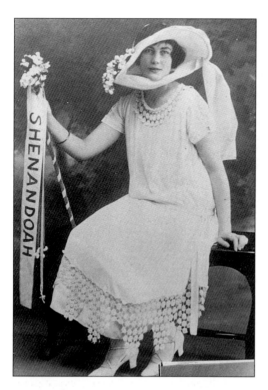

Miss Bobbie Donaldson, shown here in a studio portrait taken by an unidentified photographer, was the princess from Shenandoah County in the first festival. A princess represented each of the 13 counties located in the valley. (Courtesy of the Handley Archives Collection.)

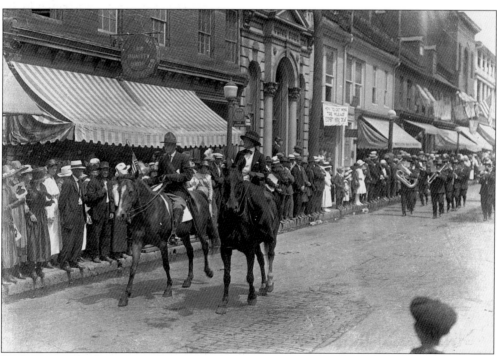

W. Spottswood White planned the first Shenandoah Apple Blossom Festival parade and served as grand marshal. Miss Isobel Wood and "Spott" White are shown in front of a band in this Barr photograph. (Courtesy of Bill Madigan.)

10

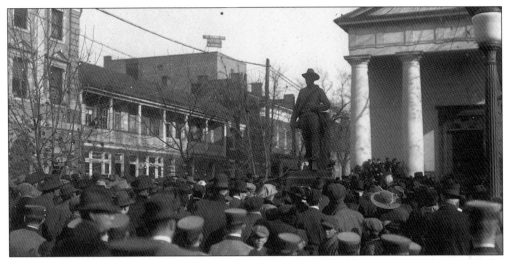

The success of the hastily arranged first Shenandoah Apple Blossom Festival inspired the community, and planning began early the following year. Two days were set aside for the festival, which began on Thursday, April 23, 1925. A very warm spring caused the trees to blossom, which accounts for the early date of the second festival. For the first several festivals, the dates were chosen by Thomas B. Byrd, whose job it was to decide when the blossoms would be at their peak. Morning exercises for approximately 5,000 school children from Winchester, Frederick, and the surrounding counties included a May Day celebration and parade through the streets of Winchester to the Handley School oval. Band concerts at the oval and at Court House Square were followed by competitive drills and athletic stunts at the fairgrounds in the afternoon. Fred Barr took this photograph of cadets and other spectators on Loudoun Street in front of the courthouse. (Courtesy of Bill Madigan.)

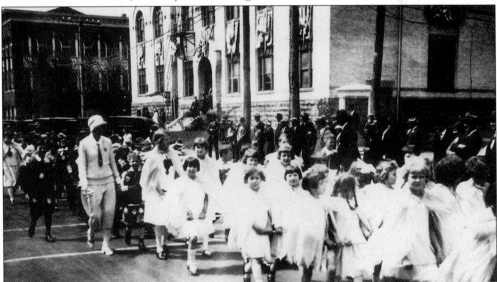

The festival's first day, which was unusually hot, ended with a night of dancing, a street carnival, an operetta in the Handley School auditorium, fireworks, and free-moving pictures. Some of the children marching on the first day of the 1925 festival are passing in front of city hall on Market Street, now Cameron Street. (Photograph by C. Fred Barr; courtesy of Handley Archives.)

11

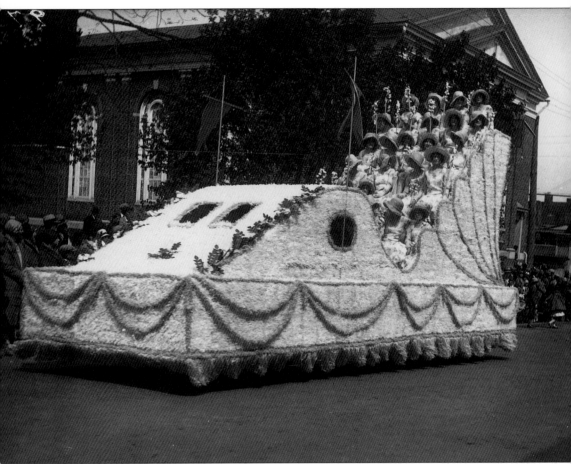

The second day of the 1925 festival began with the clergy of Winchester celebrating the festival motto, "The Bounties of Nature are Gifts from God," and concerts at the fairgrounds. In the afternoon a "Grand Allegorical Parade" thrilled a crowd of 35,000 people lining the streets of Winchester. Marching in the parade was the President's own band from the Navy Yard, Washington, D.C. The band did not usually participate in events outside of Washington that were not government occasions, but was allowed to come to Winchester because an annual recruiting drive for the different branches of the armed forces was scheduled at the same time as the festival. During the parade, the queen and her princesses were dressed as American Indian maidens. They rode in a canoe-like structure on the back of a truck. Following them was a similar canoe containing eight men dressed as braves, guards to the queen. Floats depicting the discovery of the Shenandoah Valley by the Knights of the Golden Horseshoe and subsequent settlement were next in the line of march. After reviewing the parade, the crowd at the fairgrounds was treated to a historical pageant ending with the crowning of Queen Shenandoah II. In later festivals, the queen and her court rode in more traditional floats such as this one photographed by Fred Barr. (Courtesy of Bill Madigan.)

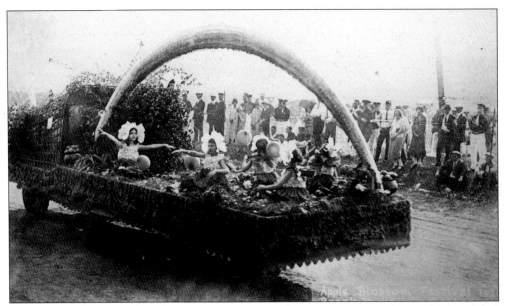

This 1925 prize-winning float from Stephens City was designed and decorated by Velma Weaver Steele. Representing one of the oldest settlements in the Shenandoah Valley, the float depicts "the pot of gold" at the end of a rainbow as one filled with apples. First chartered as Stephensburg in 1758, later as Newtown, and finally in 1887 as Stephens City, the town was surrounded by apple orchards when the first festivals were held. Many pioneer families moving west used wagons made in Newtown. Some of the famous wagons and other memorabilia can be seen when the town celebrates its heritage during a Memorial Day festival. (Photograph by C. Fred Barr; courtesy of Julia Steele Davidson.)

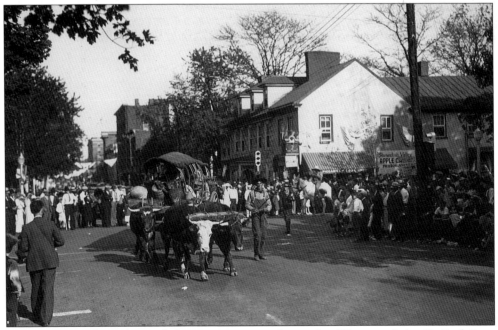

Oxen pull a replica of a settler's wagon in an early parade. (Photograph by C. Fred Barr; courtesy of Bill Madigan.)

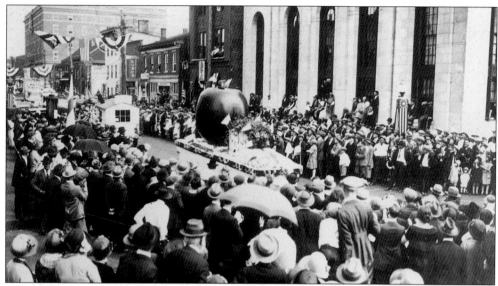

A feature that attracted much attention during the 1925 parade was a large red apple on the float created by the Benevolent and Protective Order of Elks Lodge 867. The apple was so well crafted that an offer to buy it was received from the National League of Commission Merchants of the United States, who wanted to place it in their New York club building. The Elks Lodge declined to sell and installed it on the front lawn of their building at the corner of Piccadilly and Braddock Streets in Winchester. The weather began destroying the apple, which was constructed of plaster of paris on metal lath, and the Elks replaced it with a cement version. Although the lodge moved to another building, the apple remained at the old location and can still be seen on the corner across from Handley Library. An unidentified photographer took this picture of the Elks float in the parade of 1925. (Courtesy of the Handley Archives Collection.)

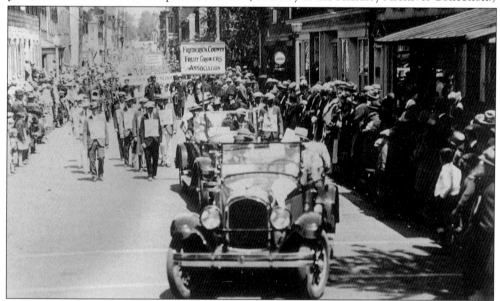

Members of the Frederick County Fruit Growers Association are shown following some official cars in this street scene taken by an unknown photographer at the first parade. (Courtesy of the Handley Archives Collection.)

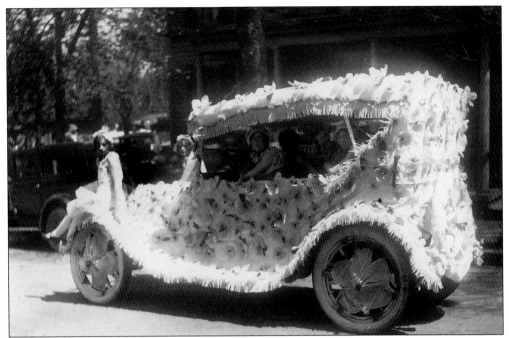

More than 150 decorated cars formed the third division of the first parade. First prize for the best decorated car in the 1924 parade was awarded to Miss Mildred Shyrock and Mrs. Paul Shyrock. This car, decorated to represent apple blossoms right down to the wheels, attracted great interest and the attention of photographer Barr. (Courtesy of Bill Madigan.)

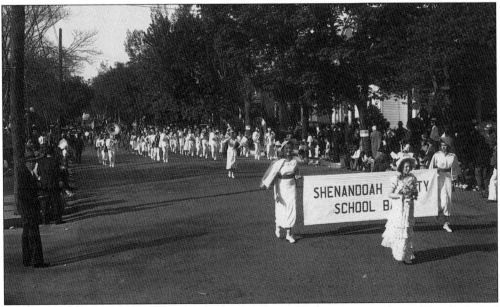

Young ladies lead the Shenandoah County School Band in an early parade. Bands and marching units from neighboring counties in Maryland, West Virginia, and Virginia have participated in the festival since its beginning. (Photograph by C. Fred Barr; courtesy of Bill Madigan.)

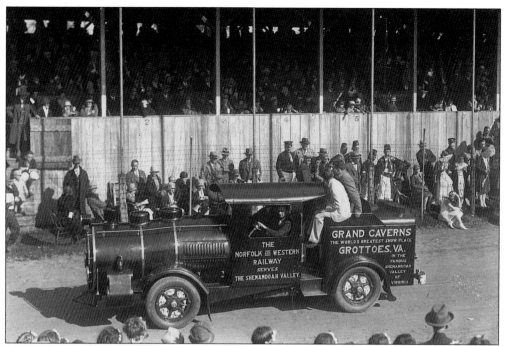

One of the trucks in an early parade, shown here in front of the grandstand at the fairgrounds, was made to look like a miniature Norfolk & Western engine. Young men ride on the back of the float, which advertises a valley attraction. (Photograph by C. Fred Barr; courtesy of Bill Madigan.)

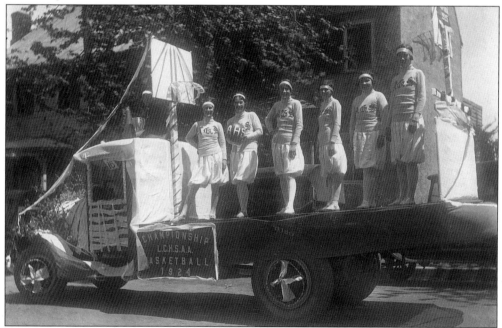

The Aldie High School basketball team rides a decorated truck with signs proclaiming the fact that they won the Loudoun County High School Athletic Association championship in 1924. (Photograph by C. Fred Barr; courtesy of Bill Madigan.)

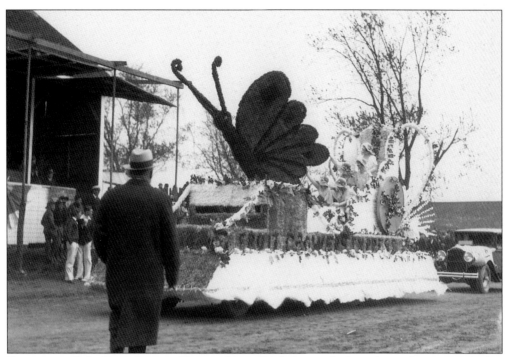

Barr captured the Fruit Growers Express float, which featured a large butterfly, as it arrived at the fairgrounds. More than 100 floats participated in the 1925 parade and passed in front of the grandstand before a pageant and coronation ceremony were performed. (Courtesy of Bill Madigan.)

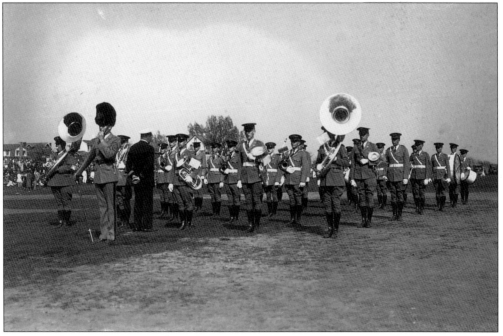

The Greenbrier Military School Band of Lewisburg, West Virginia, is ready to march in an early parade. (Photograph by C. Fred Barr; courtesy of Bill Madigan.)

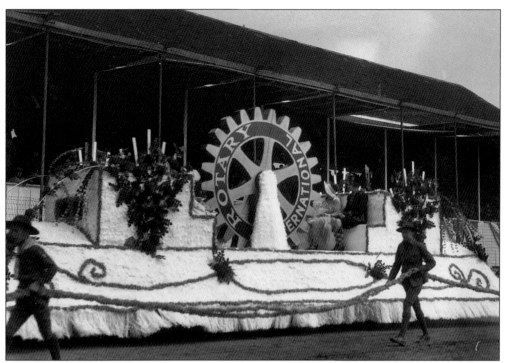

The Rotary Club is the oldest civic organization in Winchester, and the club participated in the first festival. Their float passes in front of the grandstand at the fairgrounds in one of the early parades. (Photograph by C. Fred Barr; courtesy of Bill Madigan.)

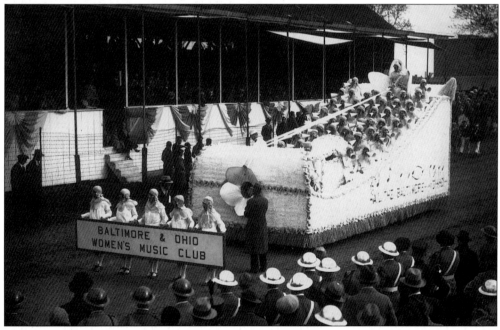

The Baltimore & Ohio Railroad was represented by a women's music club, shown here arriving at the fairgrounds. They passed in front of the queen and her court as the parade circled the grounds. (Photograph by C. Fred Barr; courtesy of Bill Madigan.)

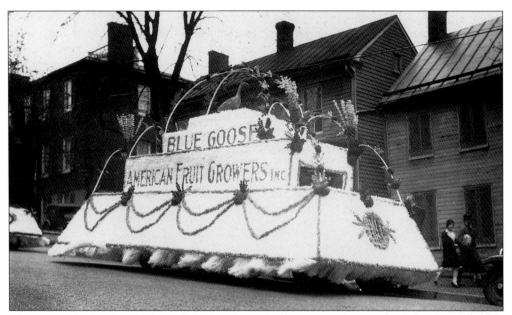

Blue Goose Orchards, members of the American Fruit Growers, Inc., created this float, which is shown waiting to join an early parade. (Photograph by C. Fred Barr; courtesy of Bill Madigan.)

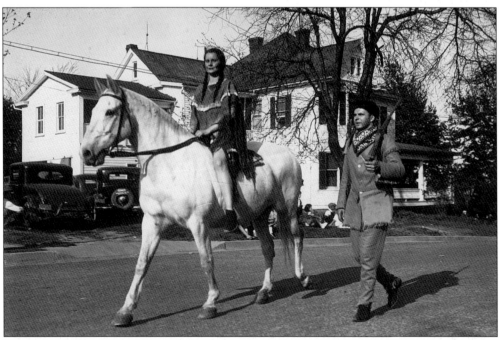

The second festival highlighted the settlement of the Shenandoah Valley by European immigrants and the peaceful relationship they had with the Native Americans in the region. The Quakers who settled along Apple Pie Ridge, an area well suited for apple growing, came to the valley with a peaceful reputation established in Pennsylvania. A couple participating in an early parade depict early valley residents. (Photograph by C. Fred Barr; courtesy of Bill Madigan.)

Queen Shenandoah

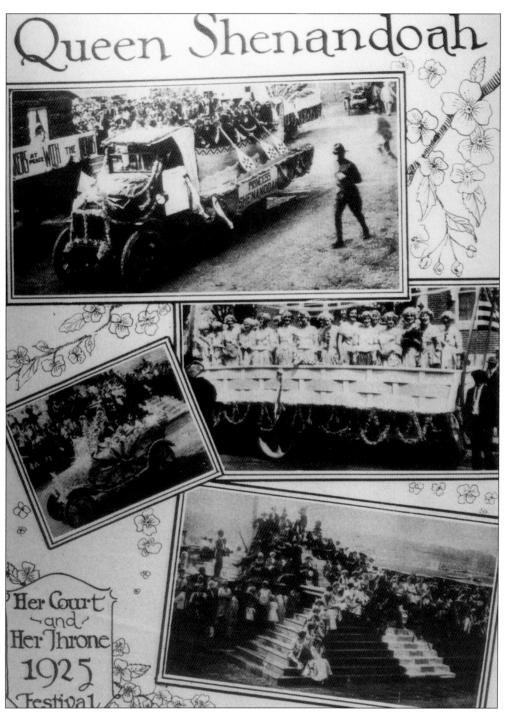

Her Court
~and~
Her Throne
1925
Festival

Fred Barr created this montage using four photographs of the second festival. The top photograph shows the Queen and and princesses arriving at the fairgrounds. In the middle are photographs of the parade, and at the bottom is the coronation of Queen Shenandoah II, Miss Eleanor Childs. (Courtesy of the Handley Archives Collection.)

Two

GROWTH AND
PROSPERITY

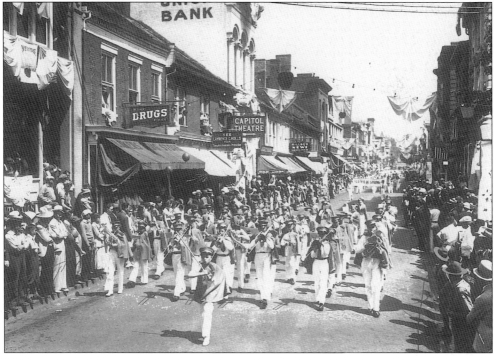

The pattern of a two-day festival, beginning with children in a "Parade of Blossoms" and ending on the second day with a grand parade, continued until 1937, when the children no longer marched in a separate parade. Third-day events were added in some years. However, the festival was primarily held on Thursday and Friday until 1974, when the main events were moved to Friday and Saturday. A band is serenading the crowd on Loudoun Street in this photograph taken by Fred Barr c. 1926. (Courtesy of Bill Madigan.)

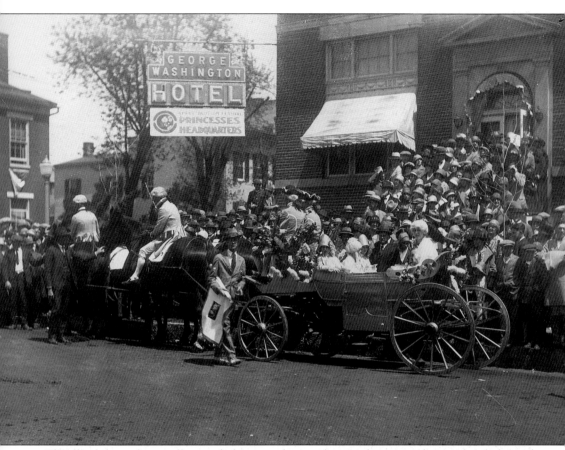

The third festival got off to a shaky start due to the weather: rain during the night and temperatures that threatened to bring frost on Tuesday. May 4, 1926, created very uncomfortable conditions for participants and spectators alike. Wednesday was warm and dry, bringing out a crowd estimated at 50,000 to watch a 4-mile-long parade. As the parade ended at the fairgrounds, Virginia governor Harry F. Byrd, a native of Winchester, crowned the queen, and a pageant was staged by John B. Rogers Producing Company, the largest pageant producers in the world. Queen Shenandoah III was the last to receive her crown at the fairgrounds. Beginning in 1927, the coronation ceremony was held at Handley School. C. Fred Barr had been appointed official photographer of the Shenandoah Apple Blossom Festival when he took this picture of queen-elect Miss Priscilla Bridges from Hancock, Maryland. Waiting to join the parade, Miss Bridges and some members of her court, dressed in colonial costumes and wigs, sit in a coach in front of the princesses' headquarters at the George Washington Hotel. (Courtesy of Bill Madigan Collection.)

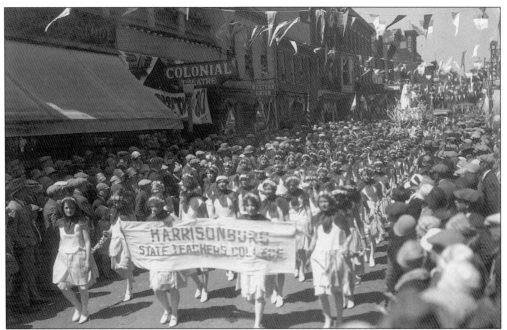

Over 600 students from the Harrisonburg State Teachers College marched in the 1927 parade. Students of the college participated in the festival from its beginning thanks to the cooperation of the college president, Dr. Samuel P. Duke. (Photograph by C. Fred Barr; courtesy of Bill Madigan.)

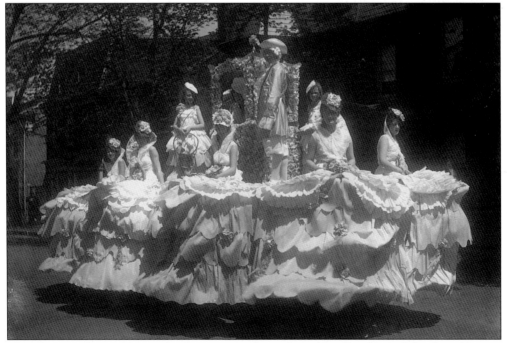

This float in the 1927 parade, featuring students from Handley High School in blossom costumes, displays a clever representation of the theme of the celebration. (Photograph by C. Fred Barr; courtesy of the Bill Madigan Collection.)

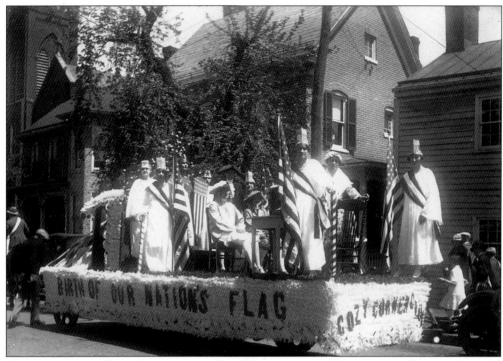

The Cozy Corner Club of Martinsburg, West Virginia, created this patriotic float for the 1927 parade. (Photograph by C. Fred Barr; courtesy of Bill Madigan.)

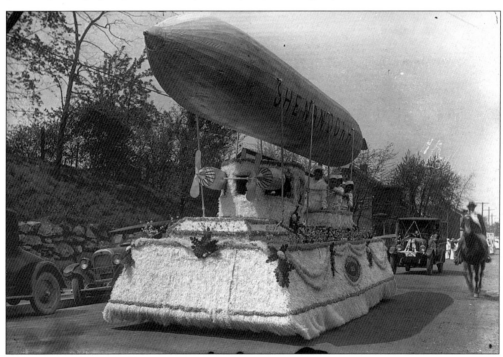

Aerial displays were a major attraction at early festivals, but this dirigible float brought air travel to earth in the 1927 parade. (Photograph by C. Fred Barr; courtesy of Bill Madigan.)

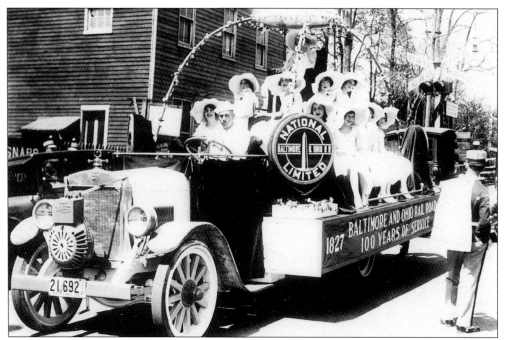

The Baltimore & Ohio Railroad (B&O) called attention to its anniversary in the 1927 parade with this float proclaiming "100 Years of Service." The B&O operated excursion trains from Baltimore; Washington, D.C.; Hagerstown; Cumberland; Martinsburg; and Strasburg Junction, advertising round-trip tickets for the price of a one-way fare. (Unidentified photographer; courtesy of the Handley Archives Collection.)

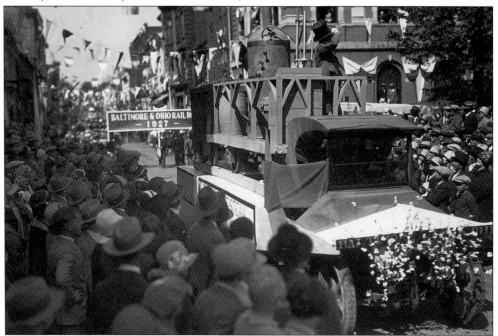

A truck, part of the B&O contingent, is having difficulty getting through the crowds on Loudoun Street. (Photograph by C. Fred Barr; courtesy of Bill Madigan.)

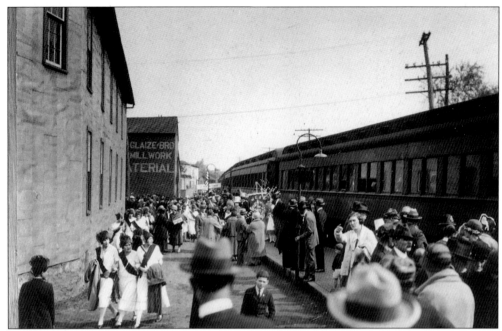

Visitors and young people hurrying to join the parade are shown arriving at the B&O Station on West Piccadilly Street in this picture taken by an unknown photographer, *c.* 1929. (Courtesy of the Handley Archives Collection.)

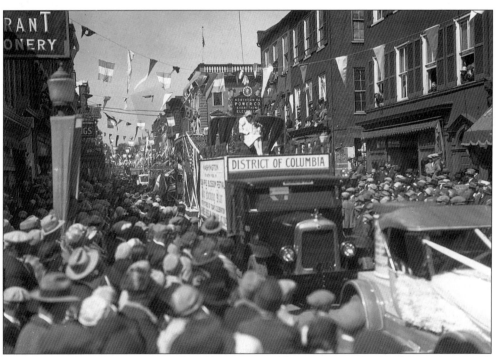

Crowd control was becoming a real problem as is readily apparent in this Fred Barr photograph of Washington, D.C.'s 1929 parade entry. (Courtesy of Bill Madigan.)

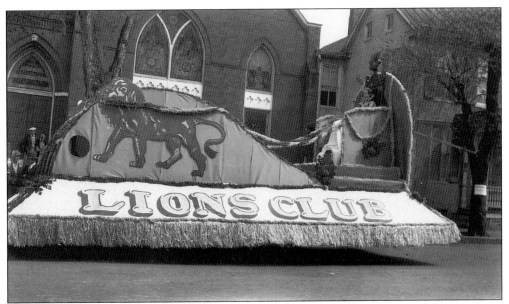

Soon after the festival became an established annual event, direction of the Grand Feature Parade was taken over by the Winchester Host Lions Club. Thousands of volunteer hours have been provided by club members to ensure the smooth operation of the parade. A Lions Club float is ready to join in an early parade. (Photograph by C. Fred Barr; courtesy of Bill Madigan.)

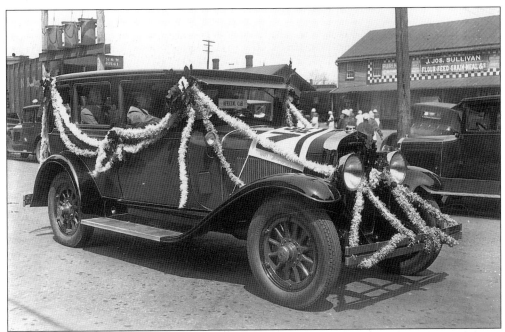

Festival officials and dignitaries rode in cars generously loaned for parades by local automobile dealers. After the formation of the Shenandoah Antique Auto Club in the 1950s, vintage cars became a welcomed part of festival events. This gaily decorated 1929 LaSalle carried some officials of the festival in the parade that year. (Photograph by C. Fred Barr; courtesy of Bill Madigan.)

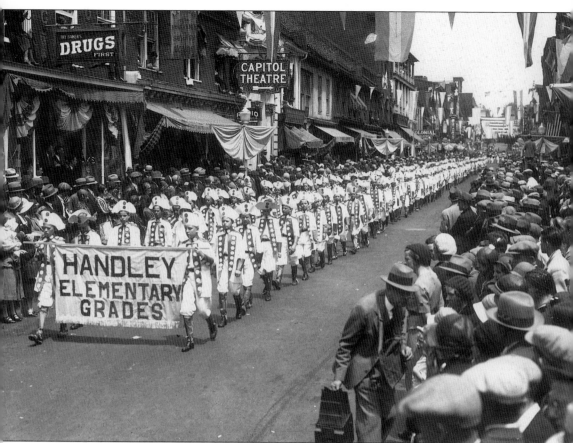

Judge John Handley (1835–1895) left his birthplace in Ireland in 1854 and became a naturalized American citizen in 1856. Little is known of Handley's early life but he served in the Pennsylvania militia during the Civil War and participated in the Shenandoah Valley campaign of 1861. His wife was from the South, where she returned after their divorce in 1874. Handley served as a judge of Luzerne and Lackawanna Counties in Pennsylvania until 1885. By that time, he had made several trips to visit friends in Winchester, a place he found very welcoming. Handley had accumulated considerable wealth, and he invested heavily in a development company in Winchester. Unfortunately, the Equity Company failed due to non-payment of subscription funds. The loss did not discourage Handley from wanting to do something of long-lasting benefit for Winchester. After numerous specific bequests, Handley left $250,000 to the city for a public library and all the residue of his estate for education of the poor, an amount in excess of $1 million. The judge would have been proud of this group of marchers in the 1928 parade representing the John Handley School, generally referred to simply as Handley. (Photograph by C. Fred Barr; courtesy of Bill Madigan.)

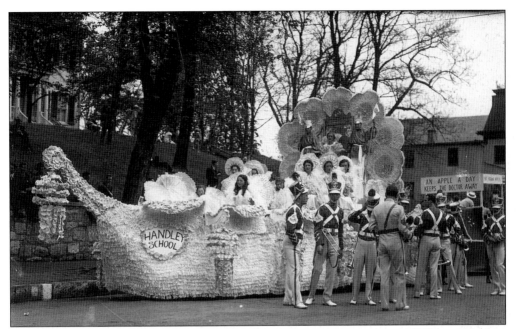

A float and band members representing Handley were waiting to join a *c.* 1930 parade when they were photographed in front of Conrad House on Cameron Street. (Photograph by C. Fred Barr; courtesy of Bill Madigan.)

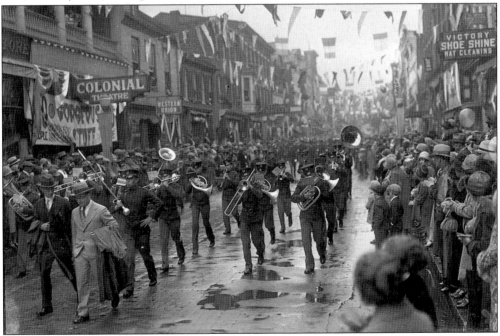

The festival has been blessed with good weather more years than not. While it was possible to make an educated guess as to when the blossoms would be at their peak, it was not always possible to predict rain. Photographer Barr took this picture of Garland Quarles and Edward P. Browning as an early parade passed crowds lining a wet Loudoun Street. (Courtesy of Bill Madigan.)

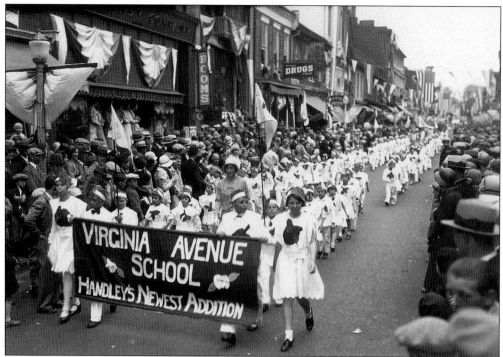

In the 1931 parade down Loudoun Street, these elementary students proudly announce the completion of the newest school constructed with Handley funds. (Photograph by C. Fred Barr; courtesy of Bill Madigan.)

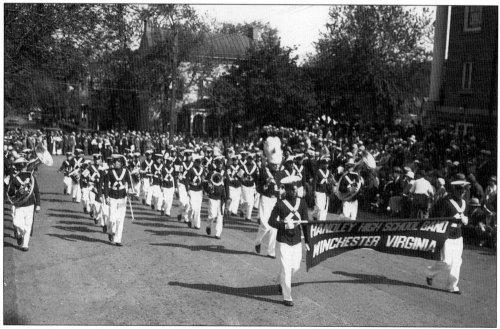

Fred Barr photographed the Handley band many times. It isn't possible to include all of the pictures. This one will have to represent all of the band members who participated during the first 50 years of the Shenandoah Apple Blossom Festival. (Courtesy of Bill Madigan.)

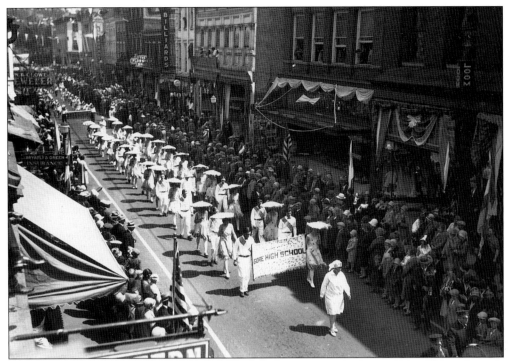

Bands and marching units from neighboring communities have contributed to festivals throughout the years. A unit of marchers from Gore High School and the Strasburg High School Band were photographed by Fred Barr during the 1928 parade. (Courtesy of Bill Madigan.)

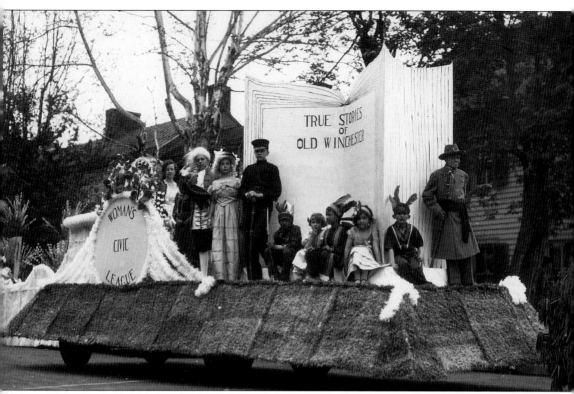

The Woman's Civic League, Inc. of Winchester was chartered in March 1915. In that year, the league campaigned for dustless streets, the elimination of flies, and a clean-up day for the city. League members were responsible for starting a popular luncheon held during later festivals. Their float in the 1928 parade is filled with children in historic costumes. (Photograph by C. Fred Barr; courtesy of Bill Madigan.)

This whimsical float was entered in the 1929 parade. (Photograph by C. Fred Barr; courtesy of Bill Madigan.)

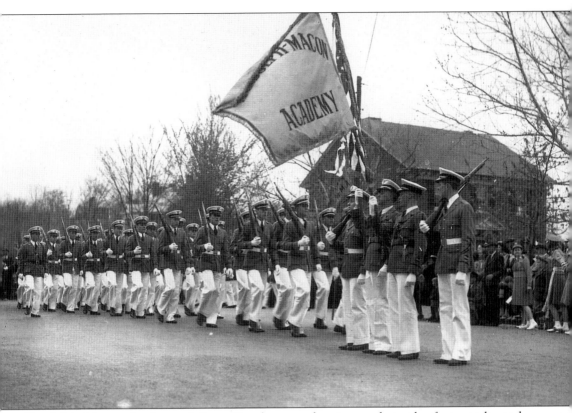

Randolph Macon Academy of Front Royal sent cadets to march in the first parade, and members of the corps participated in various capacities over the years. These students were photographed in an early parade by Fred Barr. (Courtesy of Bill Madigan.)

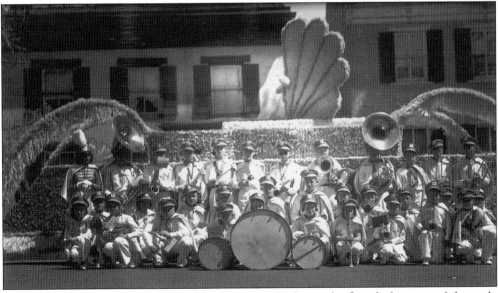

An unidentified band poses for photographer Barr in front of a float before one of the early parades. (Courtesy of Bill Madigan.)

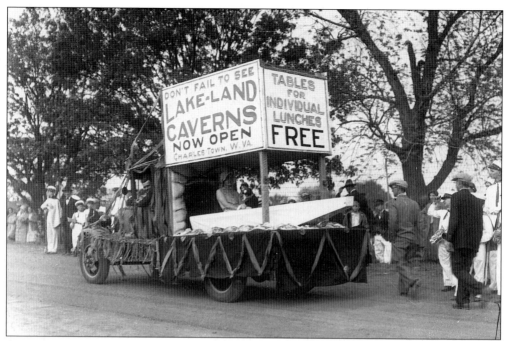

An attraction in nearby Charles Town, West Virginia, urges spectators to use their tables free and view caverns with this float in the 1932 parade. (Photograph by C. Fred Barr; courtesy of Bill Madigan.)

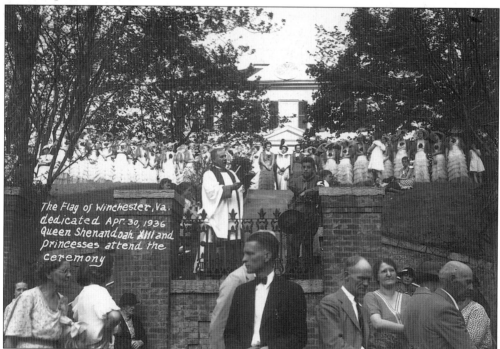

Queens participate in many functions other than official festival events. Cornelia Larus of Richmond and her court are shown in front of Conrad House for an event important in the history of Winchester. (Photograph by C. Fred Barr; courtesy of Bill Madigan.)

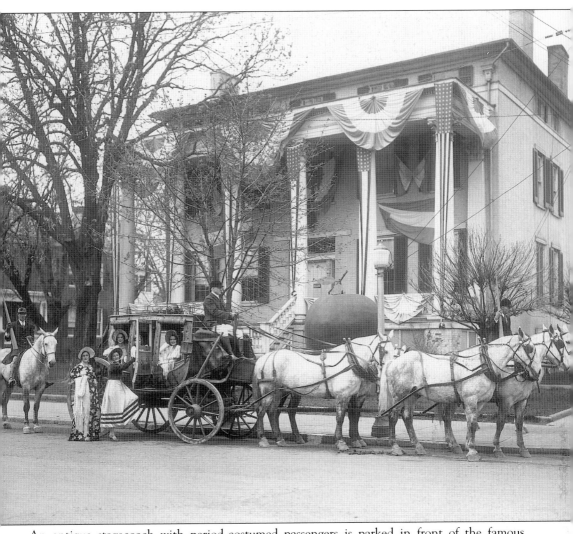

An antique stagecoach with period-costumed passengers is parked in front of the famous Elks apple during the 1929 festival. (Photograph by C. Fred Barr; courtesy of the Handley Archives Collection.)

Using photographs taken by C. Fred Barr, who died before the festival resumed after WW II, employees of his studio created this inviting poster for the 1946 event.

The Grand Feature Parade has always been the cornerstone of the festival. Thousands of Frederick County natives have been a part of the festival and thousands more have witnessed the parades over the years. The spirit of community that has made the Shenandoah Apple Blossom Festival successful does not begin and end on the first weekend in May. "T" (Teresa) Carter Hoover, on the right of this 1968 float, represents that spirit. Other "Blossomettes" on the float are Sandra Stotler, Terri Carter Ransom, and Linda Pough. (Unidentified photographer; courtesy of Rae Carter.)

Three
POMP AND GRANDEUR

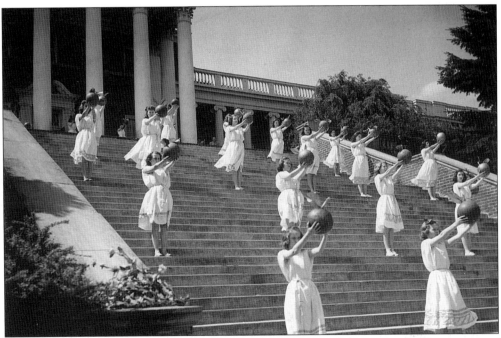

The decade of the 1930s brought about an expansion of festival features and enhancement of established events. In 1931, the pageant came under the direction of Garland Quarles, principal of John Handley School and superintendent of Winchester schools. In his official capacity, Quarles was able to direct the participation of more than a thousand school children in an extraordinary pageant staged on the steps of the John Handley School. Quarles, a native of Ruther Glenn in Caroline County, Virginia, was an English teacher at Handley School when he was asked to be principal in 1928. He became superintendent of Winchester schools in 1930 and held both positions for a number of years. Quarles continued to be the driving force behind the pageants until 1964. Students perform a standard of the pageants, the ball dance, in this c. 1950 photograph from the Virginia State Chamber of Commerce. (Courtesy of the Handley Archives Collection.)

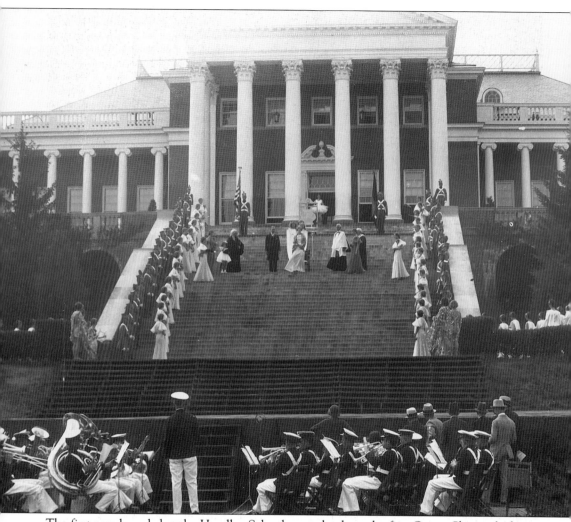

The first parade ended at the Handley School grounds where the first Queen Shenandoah was crowned. The next two coronations were held at the fairgrounds. When the program for the 1927 festival was printed, the queen was to be crowned in front of the George Washington Hotel at 7 p.m. This was changed and programs were stamped with the new time and place for the coronation ceremony—5 p.m. at the Handley School Stadium. All other coronation ceremonies since that time have taken place at Handley. The first time heavy rain made it necessary to hold the coronation in the auditorium was in 1934, when Mary Whitney, wife of John Hay Whitney, was crowned Queen Shenandoah XI. By that time the coronation ceremony had become an elaborate ritual. The Reverend Stephen L. Flickinger, pastor of the Centenary Church from 1927 until 1959, combined parts of early British ceremonies. When Queen Patricia Morton of Winchester, England, was crowned in 1931 using the new ritual, she may well have thought she was at home and not in the "colonies." Band director W.H. McIlwee and the Handley band are shown in the foreground of this Fred Barr photograph. (Courtesy of Bill Madigan.)

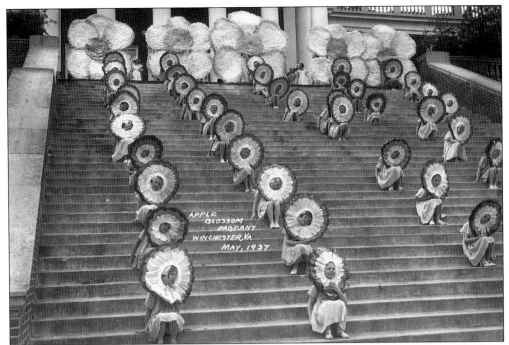

A Barr photograph shows young girls as blossoms on the steps of Handley School. From the time the school opened in 1923 until the mid-1950s, grades 4 through 12 were taught at Handley. When Quarles Elementary School was opened, elementary grades moved, while the intermediate and high school grades remained at Handley. In 1974, all grades below high school were moved from the John Handley building. (Photograph by C. Fred Barr; courtesy of Bill Madigan.)

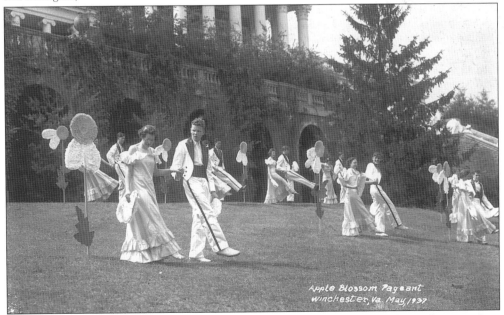

Some of the older students perform a dance on the grounds in front of Handley in a Barr photograph taken in 1937. (Courtesy of Bill Madigan.)

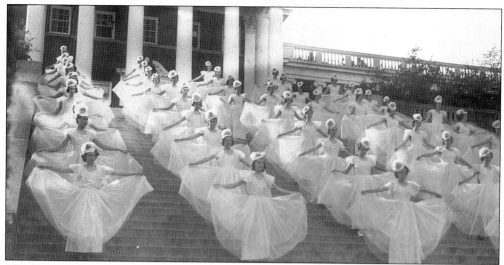

The "Famous Step Dance" captured in this photograph by C. Fred Barr in 1937 was a tradition in the pageants. (Courtesy of the Bill Madigan Collection.)

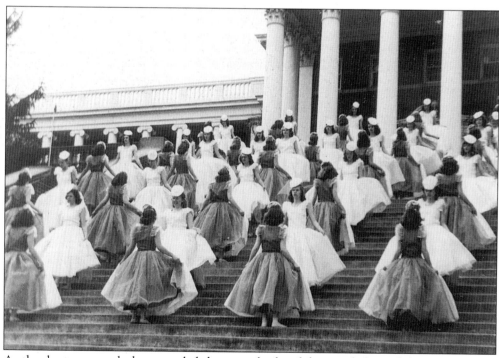

As the dancers turned, they revealed the green backs of their pink-fronted dresses creating a delightful scene for the hundreds of spectators. (Unknown photographer; courtesy of the Handley Archives Collection.)

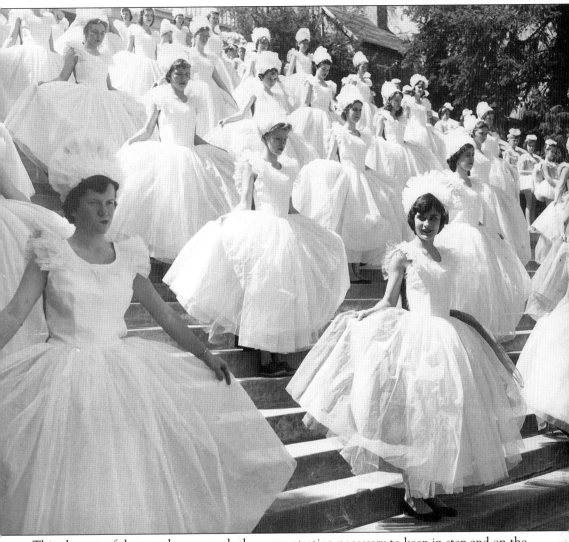

This close-up of the step dance reveals the concentration necessary to keep in step and on the steps at the same time. Sylvia Stine smiles as Tessie Shackleford concentrates. (Photograph by Barr's Studio; courtesy of Bill Madigan.)

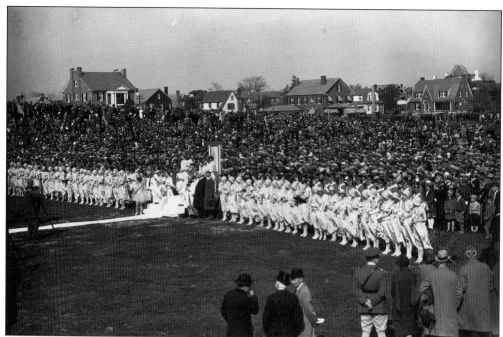

The pageant was staged at the fairgrounds for the last time in 1928. After that year, both pageants and coronations were held at Handley. Visitors to the festival in 1929 were estimated to number 75,000. Photographer C. Fred Barr has positioned himself to capture both the queen, her court, and the pageant in this photograph. (Courtesy of Bill Madigan.)

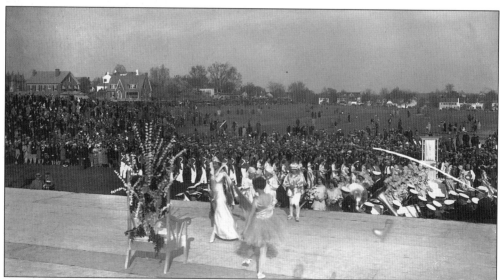

Queen Shenandoah VII, Susanne Pollard, moves regally from her pageant-viewing point to her throne overlooking the Handley oval. The houses in the background are on Handley Boulevard. (Photograph by C. Fred Barr; courtesy of Bill Madigan.)

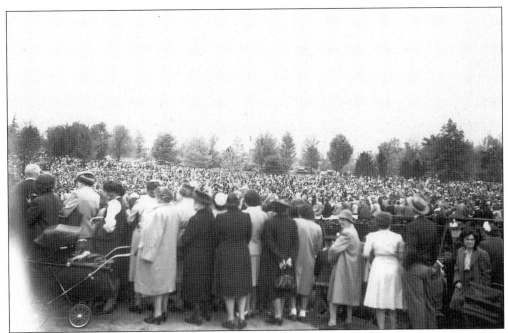

The large crowd shown here in the Handley oval testifies to the popularity of the pageant. This photograph was taken in 1946, the first year the festival was held after the interruption for WW II. (Photograph by Barr's Studio; courtesy of Bill Madigan.)

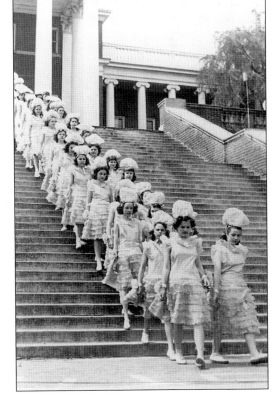

Young ladies parade down the steps of Handley during the pageant, c. 1948. Some of the girls, from left to right, are as follows: Carol Ridgeway, Ann Arthur, Patsy Carpenter, Leslie Miller, Freda Seldon, Dorothy Groves, Patricia Shank Strother, Suzanne Barr Kendall, Jane Barry, Diane Hunt, Barbara Wheeler, Marilyn Hamburger, Peggy Long, and Margaret Duckwall. (Photograph by Hugh G. Peters; courtesy of the Handley Archives Collection.)

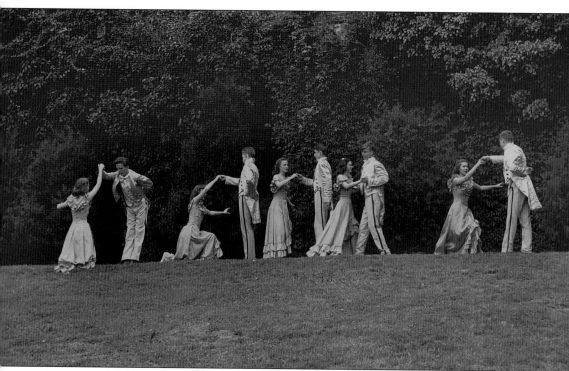

Teenagers, c. 1946, do a traditional minuet on the grass in front of Handley. The third young man from the left is Dick Chapman, and Donald Bush is half of the fourth couple. (Unknown photographer; courtesy of the Mary Ann Clowser Collection.)

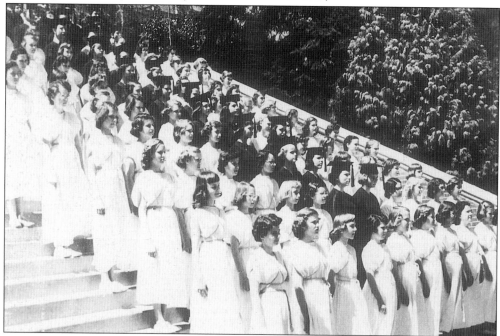

Members of the Glee Club surround seniors in this number from a 1950s pageant. (Photograph by Hugh G. Peters; courtesy of Handley Archives Collection.)

Although the theme of the pageant did not change and many of the numbers remained the same, there were always some innovations. Reynolds Legg and his partner are a part of the "Gay Nineties" group, shown dancing in a 1950s pageant. (Photograph by Hugh G. Peters; courtesy of the Handley Archives Collection.)

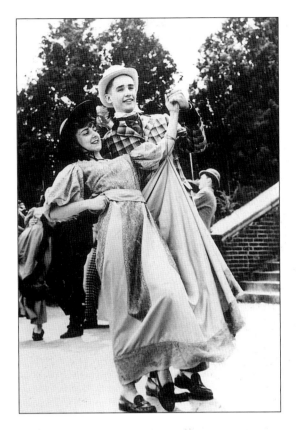

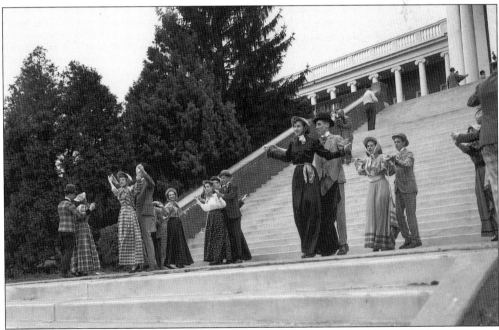

A photographer from Barr's Studio captured the "Gay Nineties" group during the same pageant. (Courtesy of Bill Madigan.)

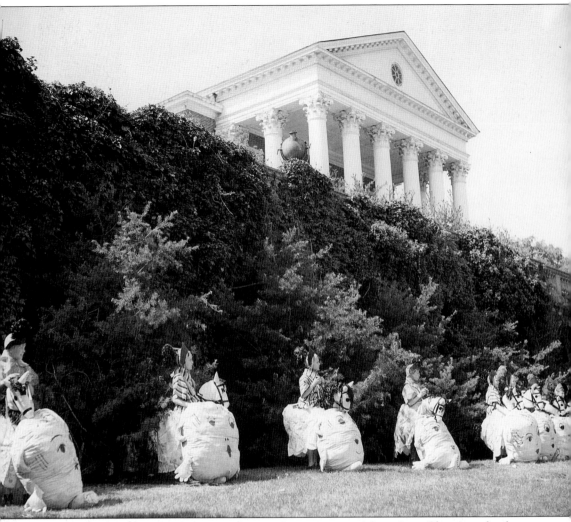

In 1964, when the job of pageant director became open, Mary Ann Clowser, who began working at the festival office in 1952, took over the responsibility. She did not have the advantage of total participation of the school population, but devised a plan using classes from volunteering schools throughout the adjoining area. Mrs. Clowser did have the advantage of being a dancer and instructor, and she staged the pageants until 1970. The young performers in this Virginia State Chamber of Commerce photograph are performing "the Humpty-Dumpty" number, which was a carry-over from earlier pageants. The children would tip the beanbag eggs in time to the music from the esplanade above and then ride their stick horses down to collect them. (Courtesy of the Handley Archives Collection.)

Weaver Photo Service of Martinsburg, West Virginia, took this picture c. 1946. The ballerinas are, from the left, Nora Crisman Garber, Micki Youngblood, Lou Ann Cather, and Nell Crisman Huntsberry. Nora and Nell are twins. The young lady seated in front is unidentified. (Courtesy of the Handley Archives Collection.)

This group from Cumberland, Maryland, was called the "Dixettes." They appeared in the numbers "Pennies from Heaven" and "Georgy Girl" in the 1971 pageant, which was directed by Mary White. (Unknown photographer; courtesy of the Handley Archives Collection.)

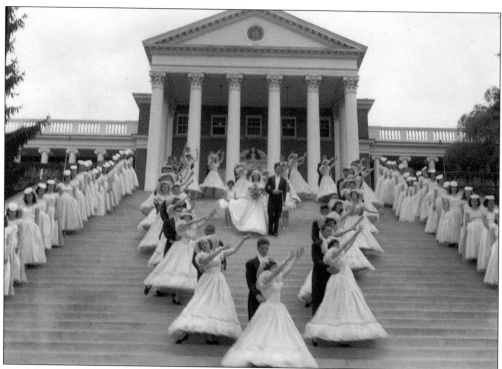

A traditional part of the pageant was the apple blossom wedding dance. The bride and groom (Gayle DeHaven) are surrounded by classmates from Handley School. (Photograph by Barr's Studio; courtesy of Bill Madigan.)

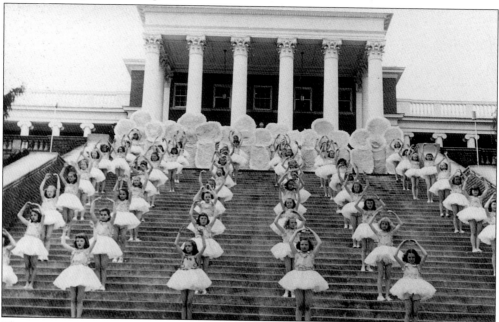

These young girls are performing the pink ballet in this *c.* 1948 photograph. In the middle of the front row is Diana Bauserman. (Photograph by Rush Studio; courtesy of the Handley Archives Collection.)

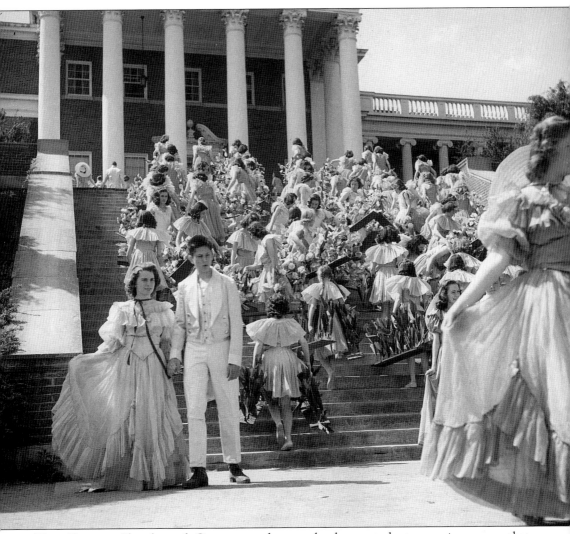

This Virginia Chamber of Commerce photograph shows students carrying props that will form a huge apple tree on the steps at the end of the dance. The young lady in the right foreground is Lillian Solenberger. (Courtesy of the Handley Archives Collection.)

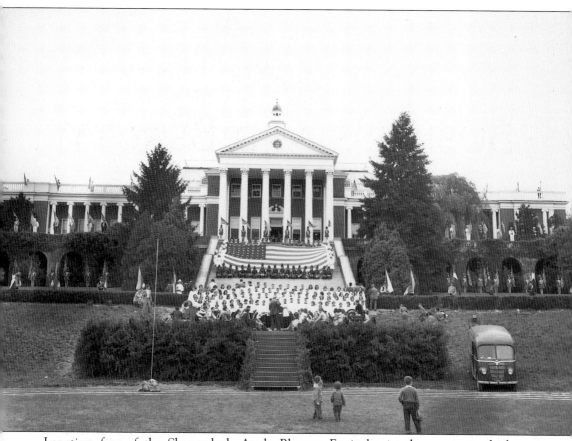

Longtime fans of the Shenandoah Apple Blossom Festival miss the pageant, which was performed for the last time in 1973. Mr. and Mrs. Hal Herman directed the last pageant called "Shenandoah March of History." Unfortunately, it was no longer possible to meet the criteria necessary for an outdoor event of this kind, that is "masses of people, moving together in a formation with lots of color," to quote Mary Ann Clowser. No matter who was directing, the pageant always ended on a patriotic note. In early days the flag was formed by students in red, white, and blue costumes. Later, as shown in this Barr's Studio photograph taken c. 1949, a large flag was unfurled across the steps as the Glee Club and Handley Band led spectators in the National Anthem. Flags along the esplanade represented other democratic nations of the world. (Courtesy of Bill Madigan.)

Four
BUSINESS AND BEAUTY

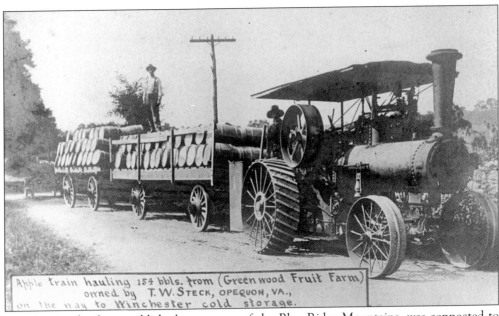

Apple train hauling 154 bbls. from (Greenwood Fruit Farm) owned by T. W. STECK, OPEQUON, VA., on the way to Winchester cold storage.

Winchester, the first established town west of the Blue Ridge Mountains, was connected to markets along the East Coast by routes through Fairfax and Loudoun Counties. Because of this access to seaports, a brisk trade was developed with England in the years following the Revolution. After the Civil War, the entire Shenandoah Valley was ravaged. Six battles and innumerable skirmishes were fought within Frederick County. Fields were left bare and uncultivated. Livestock, barns, fences, and implements were destroyed. Dr. John S. Lupton is credited with helping return prosperity to the area with the planting of the first large-scale commercial apple orchard in 1871. Thomas Steck of Greenwood in Opequon pioneered the use of scientific methods to produce improved apples, and before long he was winning awards for his work. During the period 1875 to 1920, the principal market for Virginia apples was in Great Britain, and Winchester was being called "The Apple Capital of the World." A tractor is shown taking barrels packed with apples to the cold storage facility in Winchester. (Photographer unknown; courtesy of the Handley Archives Collection.)

At the time of the first festival, an estimated $6 million was invested in Frederick County orchards and equipment and $3 million in related industries. Several factors contributed to this success. Apple growing was encouraged and, in many cases, ordered, as early settlers came to the valley. All deeds issued by Thomas Lord Fairfax after 1748 decreed that at least 100 apple trees be set upon each grant of land. The settlers found the soil conditions and weather excellent for the cultivation of apple trees. This photograph of branches laden with apples was taken by C. Fred Barr and used in the 1925 Shenandoah Apple Blossom Festival program. (Courtesy of Bill Madigan.)

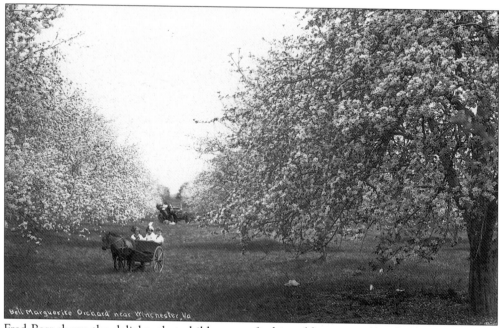

Fred Barr shows the delights that children can find in a blooming orchard. These youngsters take their miniature pony and cart through a Frederick County orchard. (Courtesy of Bill Madigan.)

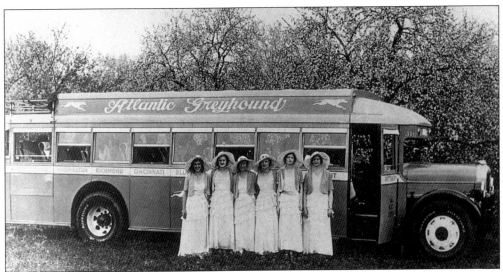

A popular feature of early festivals was touring the apple orchards. In 1924 and for the next few years, visitors were encouraged to climb into private cars and have the chauffeur take them for a 25-mile tour through the orchards, including a stop at an observation platform in C. Fred Barr's orchard, a few miles south of Winchester. As more automobile traffic came to Winchester, a self-drive tour was mapped out and directional signs pointed the way through the blooms. By 1947, festival organizers were offering all-day bus service for tours through the groves. A Greyhound bus provided transportation for members of the 1936 court accompanying the queen, Miss Cornelia Larus, to the orchards. (Photograph by W.E. Bollinger, Charleston, West Virginia; courtesy of the Handley Archives Collection.)

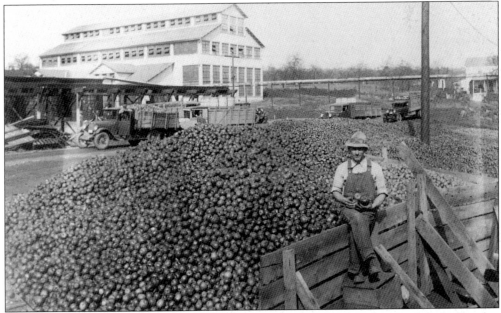

This photograph of temporary apple storage for cider and vinegar and an unidentified worker in front of the Winchester Cold Storage Plant was used in the 1925 official Shenandoah Apple Blossom Festival program. (Photograph by C. Fred Barr; courtesy of the Handley Archives Collection.)

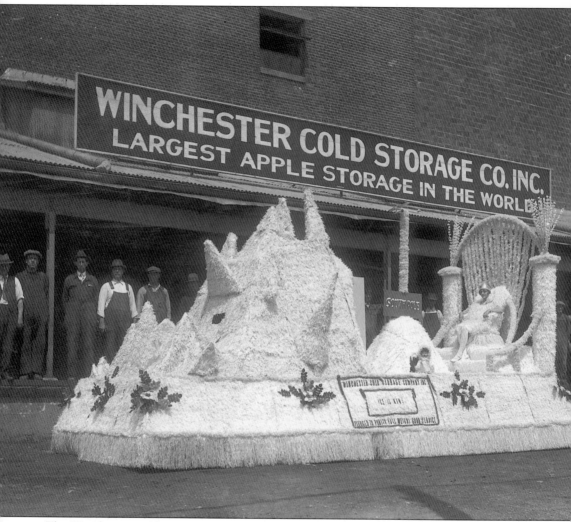

The Winchester Cold Storage Company was incorporated in 1917 to acquire orchards and land on which to erect a cold storage plant. The officers of the new corporation intended to can and preserve fruit and vegetables. It was also their intention to manufacture ice to sell to the local populace. The company built a massive refrigeration building in 1917 and apple storage buildings in 1922 and 1929. By 1957, Winchester Cold Storage also owned its own packing house, which was leased to other companies until it was closed in 1979. Over a million bushels of apples could be stored at the facility located on North Loudoun Street adjacent to the early fairgrounds. C. Fred Barr photographed a float representing the Winchester Cold Storage Plant in an early festival in front of several workers standing on the loading dock. (Courtesy of Bill Madigan.)

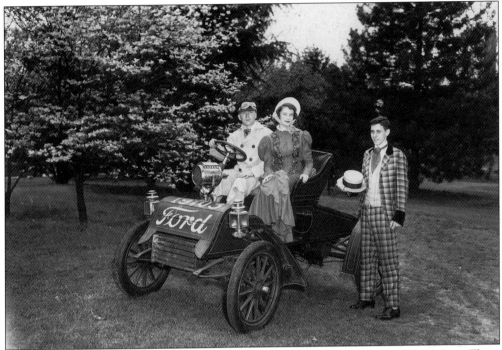

The orchards provided a lovely background for costumed festival participants. Three unidentified people enjoying the blooms pose in a 1903 Ford. (Photograph by C. Fred Barr; courtesy of Bill Madigan.)

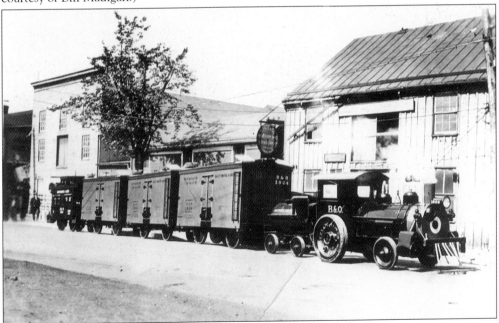

A miniature B&O train is ready for the 1927 festival parade. Shown in front of the Snapp Foundry Sign on North Market (Cameron) Street, the miniature represents the importance of railroads as a means of shipping apples and related products to both United States and foreign markets. (Photographer unknown; courtesy of the Handley Archives Collection.)

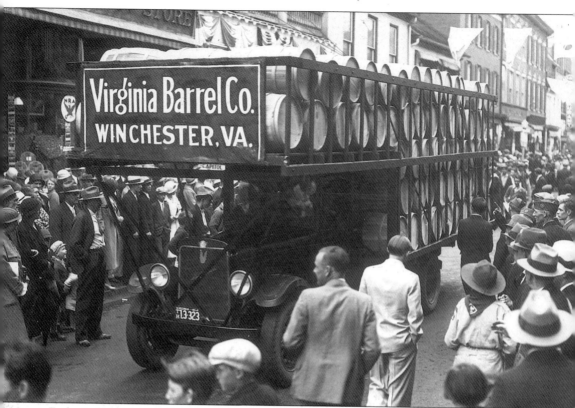

Early apple growers preferred to use barrels as containers to ship apples. The Winchester Barrel Company proudly displays some of their wares in an early parade. (Photograph by C. Fred Barr; courtesy of Bill Madigan.)

The importance of railroads to the prosperity of the apple industry and the economic well-being of Winchester cannot be overemphasized. These two elaborately decorated cars carry representatives of some railroad companies in an early parade. (Photograph by C. Fred Barr; courtesy of Bill Madigan.)

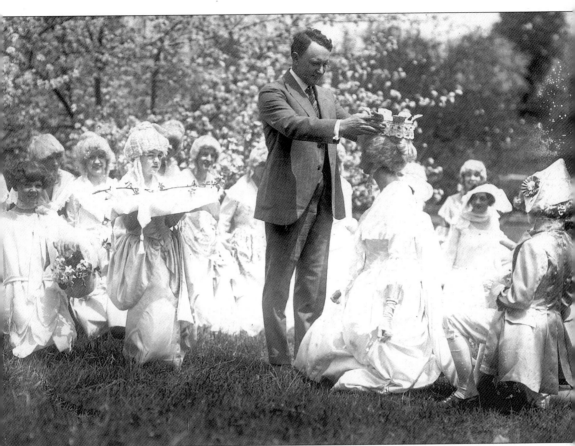

Although the official coronation took place at the fairgrounds, the minister of crown, queen, and her court are shown in a coronation staged in an orchards in 1926. Virginia governor Harry Flood Byrd of nearby Berryville in Clarke County crowns Queen Shenandoah III, Priscilla Bridges, amid blossoms. They are surrounded by some members of her court in colonial costumes and wigs. At this festival, there were 161 princesses, representing the 13 original states, the 48 states of the Union at that time, and the 100 Virginia counties. (Photograph by C. Fred Barr; courtesy of Bill Madigan.)

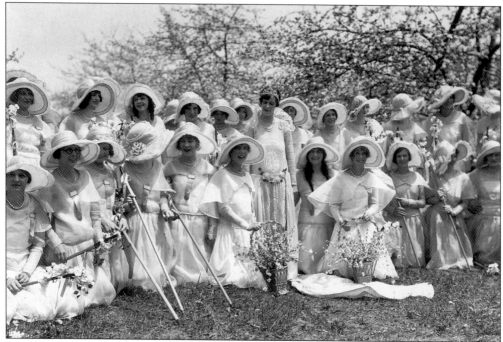

Mary Wise Boxley of Roanoke, Virginia, was crowned Queen Shenandoah in 1928. She poses here with her court in a traditional orchard photograph. (Photograph by C. Fred Barr; courtesy of Bill Madigan.)

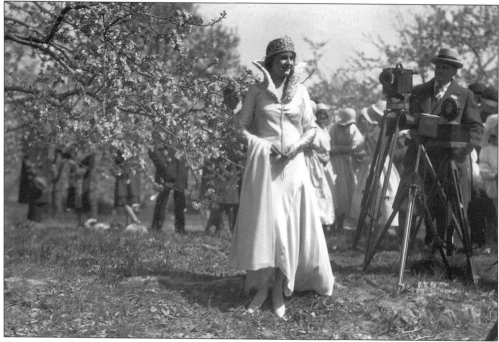

Queen Shenandoah VII, Susanne Pollard, daughter of Virginia governor Garland Pollard, carries on the tradition of enjoying the blossoms in her regal gown. Other photographers were captured by C. Fred Barr in 1930 as they record the moment. (Courtesy of Bill Madigan.)

A special feature of the 1930 festival included invitations to five prominent citizens of Winchester who had attained worldwide recognition. Photographs and biographies were included in the official program of Admiral Louis McCoy Nulton, Willa Sibert Cather, Dr. Frederick Henry Baetjer, Dr. James Howard Gore, and Rear-Admiral Richard Evelyn Byrd. The *New York Times* of April 20, 1930, listed Winchester as one of the ten most interesting places in the world. Queen Pollard is shown with her court and minister of crown, Georgia governor L.G. Hardman, as they survey a blooming orchard in this interesting place. (Photograph by C. Fred Barr; courtesy of Bill Madigan.)

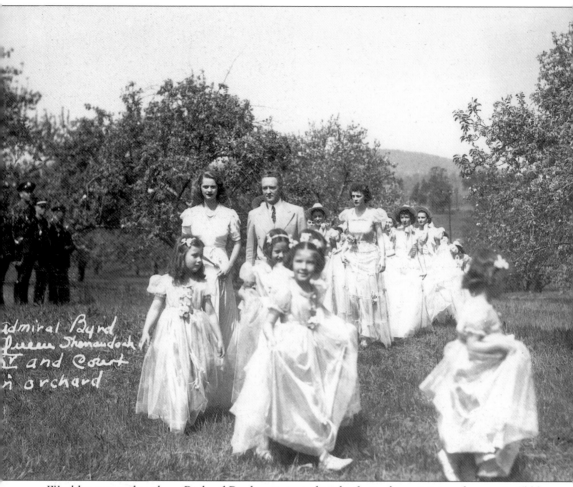

World-renowned explorer Richard Byrd participated in the festival as minister of crown in 1928 and again in 1931. When Frederick County celebrated its bicentennial in 1938, Byrd once again served in that capacity. He is shown here escorting Queen Shenandoah XV, Adelaide Moffett, on a tour of an orchard. (Photograph by C. Fred Barr; courtesy of Bill Madigan.)

Using apple blooms as a background, photographer Barr created this portrait of the 1931 queen, Patricia Morton of Winchester, England. A committee of citizens of the ancient capital for which Winchester, Virginia, was named, chose Patricia as Queen Shenandoah VIII at the request of festival officials. (Courtesy of Bill Madigan.)

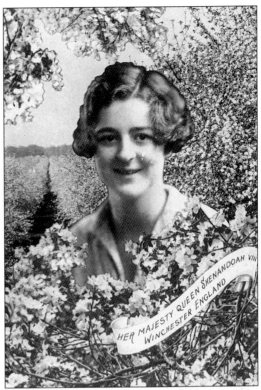

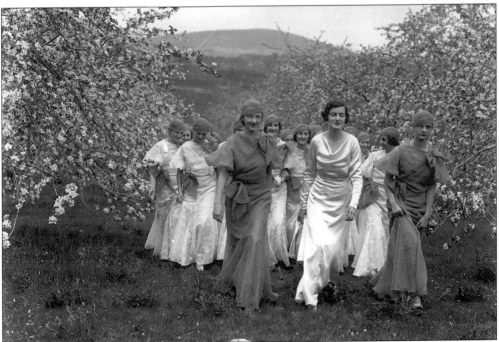

Queen Shenandoah X, Miss Francoise May, daughter of Paul May, ambassador from Belgium to the United States, is shown walking through a grove with her court during the 1933 festivities. (Photograph by C. Fred Barr; courtesy of Bill Madigan.)

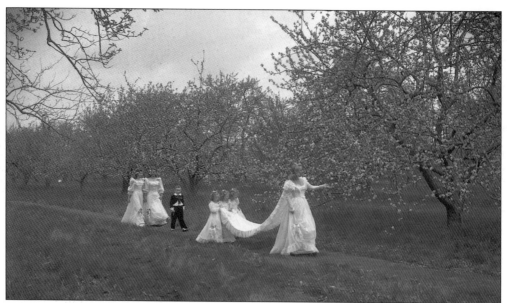

Taking a royal stroll through the blooming trees in 1948 is Queen Shenandoah XXI, Miss Gretchen Merrill. The Creedle triplets, Temple Lee, Betty Jean, and Carroll Ann, are the trainbearers. James Kenneth Robinson Jr., whose father was a member of the court of the first Queen Shenandoah, is followed by the Maids of Honor, Adalaide Coble and Jo Ann Armstrong. (Photograph by Barr's Studio; courtesy of Bill Madigan.)

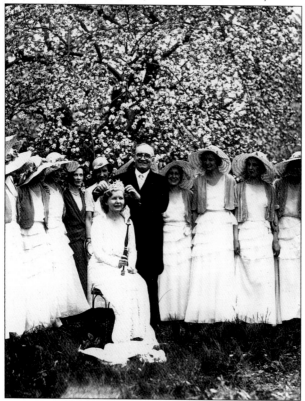

Reenacting the coronation are Queen Shenandoah IX and her Minister of Crown, Paul Claudel, U.S. ambassador to France. Miss Helen Ames Washington was asked to serve as queen in 1922, the year marking the 200th anniversary of George Washington's birth, because she was a member of the Washington family. (Photograph by C. Fred Barr; courtesy of Bill Madigan.)

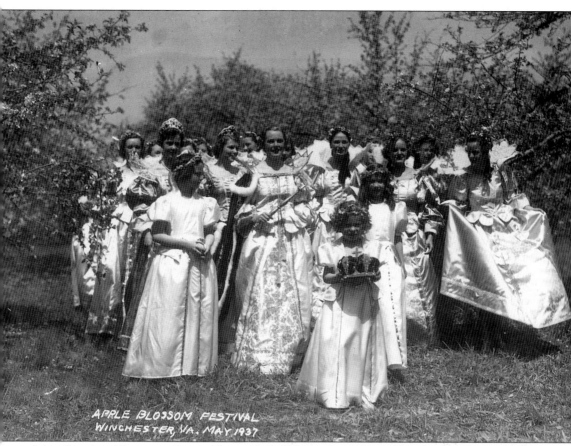

APPLE BLOSSOM FESTIVAL
WINCHESTER, VA. MAY 1937

Miss Gretchen Thomson, Queen Shenandoah XIV, and members of her beautifully costumed court were photographed by Fred Barr in 1937. Miss Thomson caught the eye of Harry F. Byrd Jr., a festival volunteer, and they were married in 1941. Harry F. Byrd Jr. served in the Virginia state senate from 1948 until he became a United States senator in 1965. The Byrds divided their time between Washington, D.C., and "Courtfield," their home in Winchester. Many of the queens stayed at the Byrd residence. Mrs. Byrd passed away in 1989 but former Senator Byrd continues to support the festival and participate in many public and philanthropic activities. (Courtesy of Bill Madigan.)

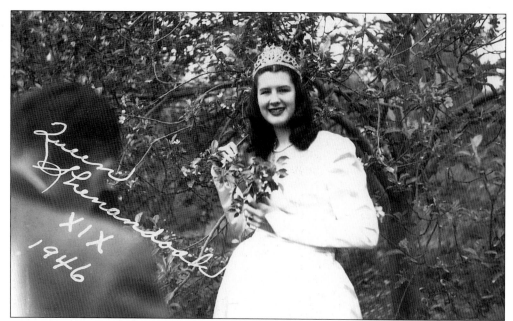

When the festival resumed in 1946, the first post-war Queen Shenandoah was Nancy Anderson of Albuquerque, New Mexico. She is shown in this photograph in an orchard past peak bloom. Unfortunately, with the many advance preparations necessary to stage the largest festival in Virginia, it was no longer possible to select the dates at the last minute when the blossoms could be guaranteed as had been done for earlier festivals. Therefore, the festival does not always coincide with the best bloom. (Photograph by Barr's Studio; courtesy of Bill Madigan.)

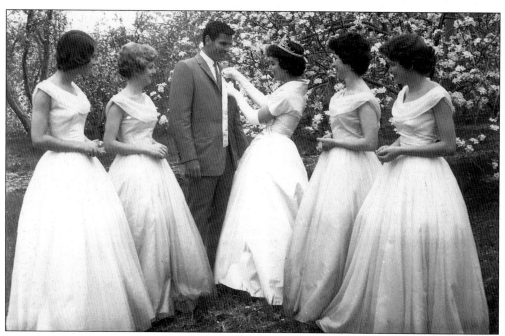

Tom Tyron, grand marshal of the 1960 parade, is being pinned by Queen Yvonne Mendonca of Honolulu in this Barr's Studio photograph. (Courtesy of Bill Madigan.)

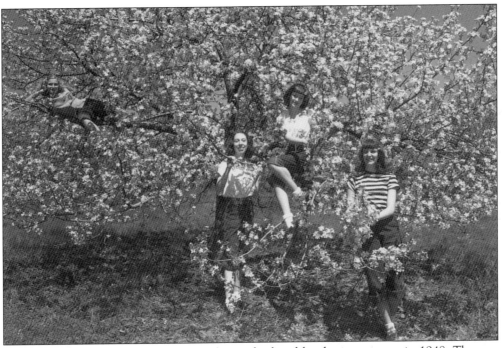

The orchards also provided a place for fun as displayed by these teenagers in 1948. The tree climbers are, from left to right, Shirley Long Marshall, Jean Miller, Page Michael, and Carol Cain. All were dance students at Ewing Studio. In the photograph below, Carol and Jean had changed into costumes to perform a graceful dance among the blossoms. (Photograph by Barr's Studio; Courtesy of Bill Madigan.)

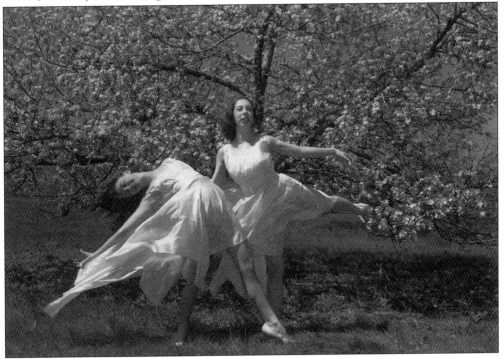

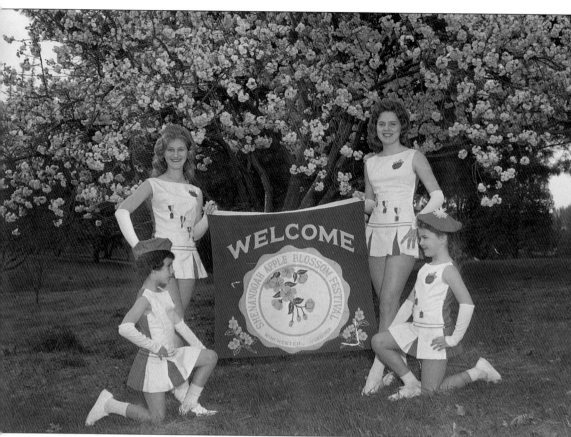

Bambi Clowser, kneeling on the left across from her friend, Patty, joins Sandy Holbrook, on the right, and Sandy Brooks, in providing this 1950s welcome to visitors in front of a beautiful blooming apple tree. (Photographer unknown; courtesy of the Mary Ann Clowser Collection.)

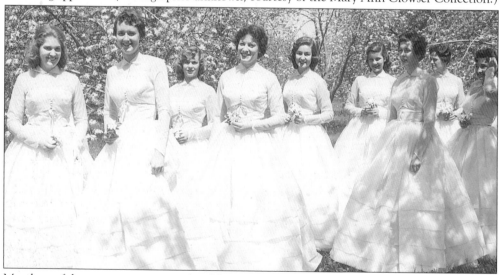

Members of the court pose in an orchard for a Barr's Studio photographer in 1962. (Courtesy of Bill Madigan.)

Five
SERVICE AND FUN

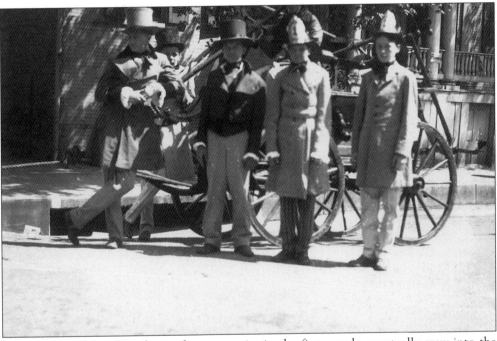

Participation of four Winchester fire companies in the first parade eventually grew into the world's largest annual congregation of firefighters and equipment. In 1929, organizers set aside the night before the grand feature parade, coronation, and pageant for a torchlight parade that began at 8 p.m. This evening parade continued until 1934 and featured firemen and mummers (costumed participants). Although no evening parade was held during the next three years, the event was again staged in 1938 as the Rouss firemen's parade. During the three years before the break for WW II and from 1946 until 1949, a torchlight parade was held on Thursday night. In 1950, the event was established as a firemen's parade, which began at 6:30 on Thursday night. The parade was changed to Friday night and the name was changed to the Firefighter's Parade to embrace all of the participants in 1971. By 1974, when the Firefighter's Parade was moved up to 5 p.m., six states were represented in the event. Besides staging the largest parade of its kind in the world, Winchester firefighters were also responsible for fireworks displays when they were held during the first 50 festivals. These unidentified lads pose in front of early firefighting equipment. They appear ready to step into an early festival parade. (Photograph by C. Fred Barr; courtesy of Bill Madigan.)

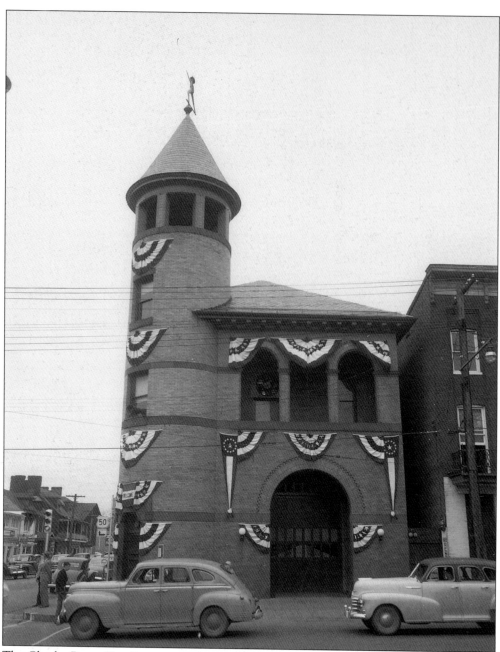

The Charles Rouss Fire Company is decorated and ready to receive festival dignitaries in this *c.* 1945 photograph. Charles Rouss (1836–1902), a Winchester native, made a fortune in New York after his move there in 1866 by developing an auction business and mail-order catalogue. Although Rouss changed his middle name from Baltzell to Broadway, he never forgot his hometown. He returned often and became one of Winchester's benefactors. In addition to donating more than $25,000 to Winchester fire companies, including the Union Steam Fire Company, which was renamed in his honor, Rouss gave almost half of the funds to erect the city hall, also named for him. (Photograph by Barr's Studio; courtesy of Bill Madigan.)

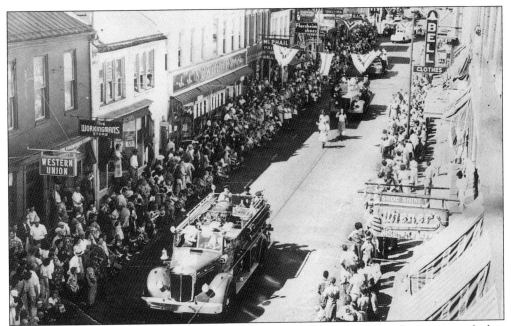

When Sarah Zane, the sister of General Isaac Zane Jr., came to Winchester to settle her brother's large estate, she was impressed with the town. Upon her death, she left $1,000 for the citizens to purchase a fire engine and hose. In 1840, the volunteer Sarah Zane Fire Company was established and served the citizens of Winchester until the 1980s, when the company was officially disbanded and members joined the Rouss Fire Company. A Sarah Zane truck leads others on North Loudoun Street in this overhead photograph of an early festival parade. (Unknown photographer; courtesy of the Handley Archives Collection.)

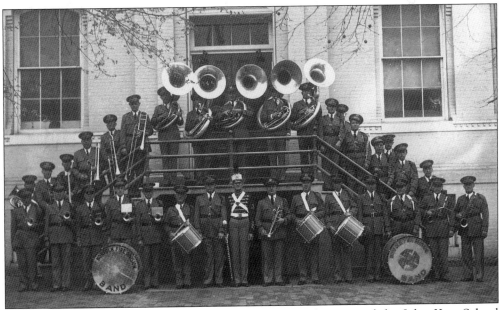

Members of the Norfolk Fire Company Band pose on the steps of the John Kerr School before joining one of the early parades. (Photograph by C. Fred Barr; courtesy of Bill Madigan.)

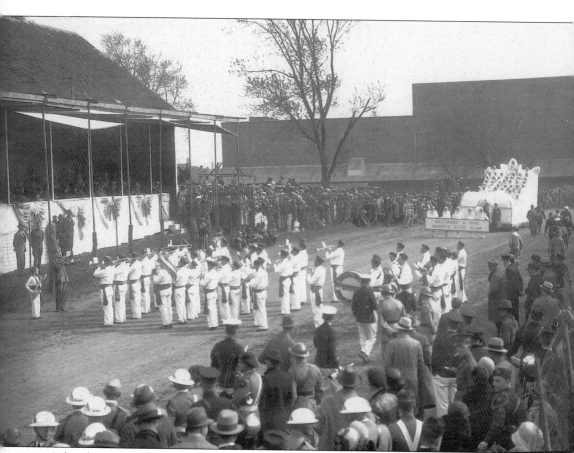

A band performing in front of the grandstand at the fairgrounds, c. 1927, is typical of the mummers units that would later be part of an evening parade. (Photograph by C. Fred Barr; courtesy of Bill Madigan.)

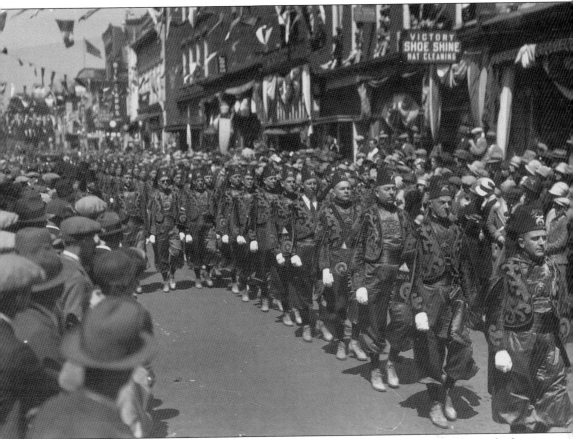

Units such as this one from the Acca Temple in Richmond, photographed in 1927, marched in the evening torchlight parades beginning in 1929. The late-day, low-light timing of the parade and early equipment did not permit even the best of photographers to capture the parade, which for many years was held after dark on the first night of the festival. (Photograph by C. Fred Barr; courtesy of Bill Madigan.)

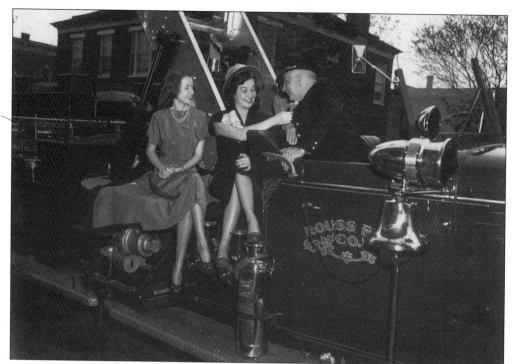

The 1949 Rouss Fire Company chief entertains Ann Adams, on the left, and Queen Margaret Thors. The group is shown in the picture below in front of the George Washington Hotel, where the festival office was located. (Photograph by Barr's Studio; courtesy of Bill Madigan.)

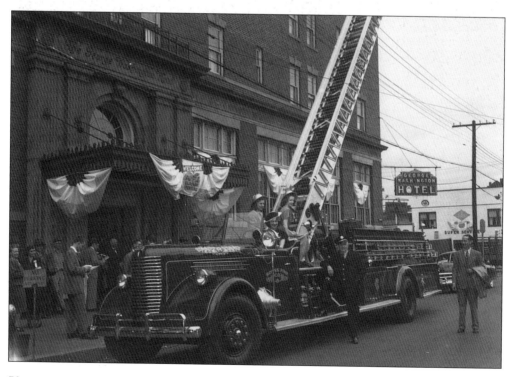

Gifts are being presented in this photograph taken at the Friendship Fire Company. From left to right, Meade Dorsey, Claude Smaltz, D. O'Connell, and Rollin Conner are shown with Russ Tamblyn and an unidentified young lady. Tamblyn, an actor, was serving in the Army when he was the 1961 grand marshal of the Firemen's Parade. (Photograph by Barr Studio's; courtesy of Bill Madigan.)

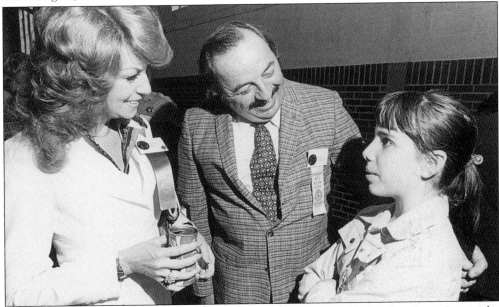

By 1950, the parade was so popular that a celebrity marshal was added. Fulton Lewis Jr. was the first firemen's marshal, followed by Harry Wismer and other radio personalities. Later, Olympic champions, including Shelley Mann in 1961 and Jesse Owens in 1970, led this one-of-a-kind parade. Country music was represented with Dottie West leading the firefighters in 1964 and returning in 1977. She is shown here greeting a young fan and Bob Taylor, director of the Firefighters' Parade during the 50th anniversary festival. (Photograph by Mark L. Ainsworth; courtesy of the Handley Archives Collection.)

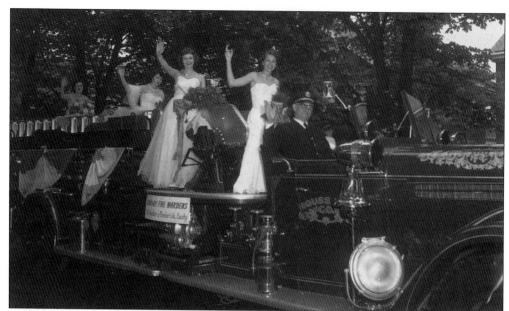

Over the years, the local fire companies have made the parade and competitive events extraordinary. In true host spirit, they do not share in the prizes that were first awarded in 1926. The competition that year was announced as "Open to the World," and three cash prizes totaling $400 were awarded. Honorary fire wardens greet spectators from a Rouss Fire Company truck during the 1951 parade. (Photograph by Barr's Studio; courtesy of Bill Madigan.)

Members of the Harrisonburg, Virginia Fire Company are proud of their well-turned-out equipment that is ready for the 1951 parade. (Photograph by Barr's Studio; courtesy of Bill Madigan.)

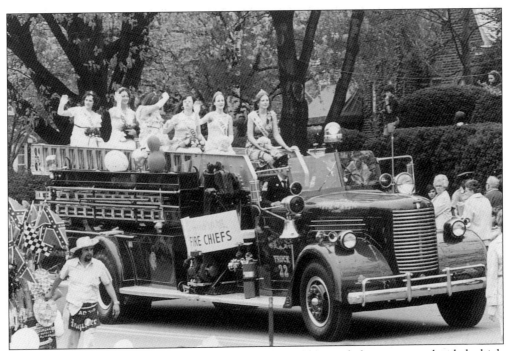

In-town and out-of-town honorary fire chief contests held by each fire company decided which young ladies will ride in the parade participate in other events at the festival. Some honorary fire chiefs enjoy waving to the crowd during the 1974 parade. (Photograph by Mark L. Ainsworth; courtesy of the Handley Archives Collection.)

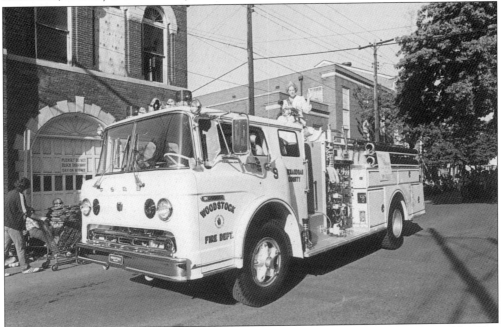

The Woodstock honorary fire chief rides on top of a truck passing in front of the Friendship Fire Company building during the festival's 50th anniversary Firefighters' Parade. (Photograph by Mark L. Ainsworth; courtesy of the Handley Archives Collection.)

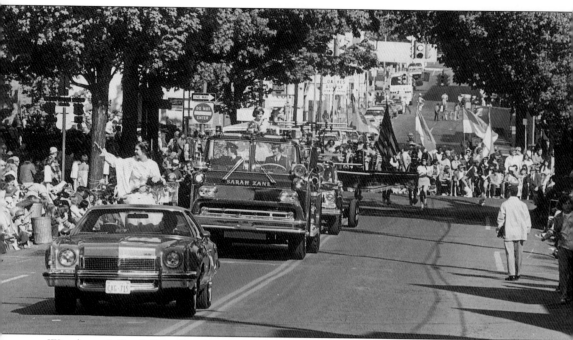

Winchester's Sarah Zane Fire Company's honorary chief waves to the crowd as the truck passes during the 50th anniversary Firefighters' Parade. (Photograph by Mark L. Ainsworth; courtesy of the Handley Archives Collection.)

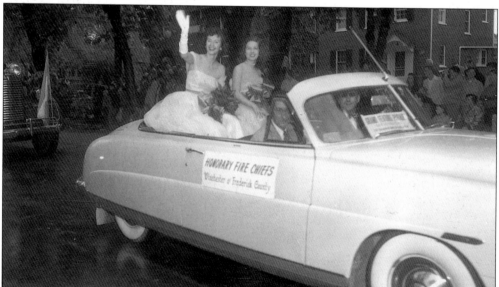

In 1970, when Winchester annexed the area served by Shawnee volunteer firemen, the company became part of the host team made up of Friendship, Rouss, Sarah Zane, and South End fire companies. Changes in the city's fire departments and their jurisdictions has not lessened the enthusiasm which they bring to the Firefighter's Parade and related events. Honorary fire chiefs representing Winchester and Frederick County wave to the crowd from a 1950s Hudson. (Photograph by Mark L. Ainsworth; courtesy of the Handley Archives Collection.)

Six

CELEBRITIES AND CROWDS

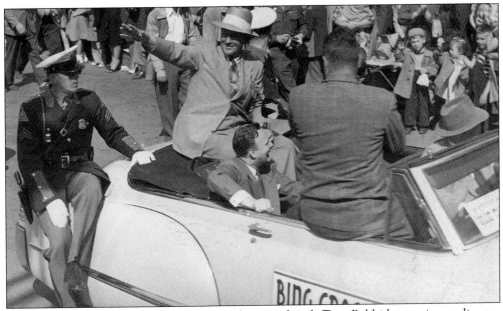

In 1946, when WW II was over, the festival resumed with Tom Baldridge serving as director general, a job he had first undertaken in 1938. As the East Coast representative of Metro-Goldwyn-Mayer, Mr. Baldridge was in a unique position to arrange celebrities' schedules to include a trip to Winchester. The first to accept Baldridge's invitation was the very popular Bing Crosby, who thrilled the crowds in 1948 when he served as grand marshal of the Grand Feature Parade. Thus began the celebrity era of the Apple Blossom Festival. Hollywood's brightest stars, as well as television and sports personalities, brightened future festivals and drew crowds numbering over 200,000 to Winchester. Grand Marshal Bing Crosby greets parade viewers in 1948. (Photograph by Barr's Studio; courtesy of Bill Madigan.)

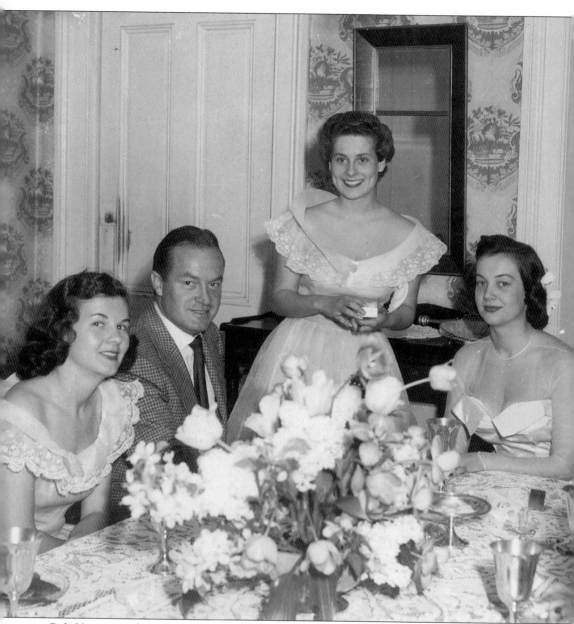

Bob Hope, grand marshal of the 1949 parade, entertains Queen Shenandoah XXII, Margaret Thors of Iceland, during his first visit to the Shenandoah Apple Blossom Festival. Standing between the comedian and Miss Thors is Elizabeth Steck Arthur, daughter of the first queen. Diana Hunt is seated on Hope's right. (Photograph by Barr's Studio; courtesy of Bill Madigan.)

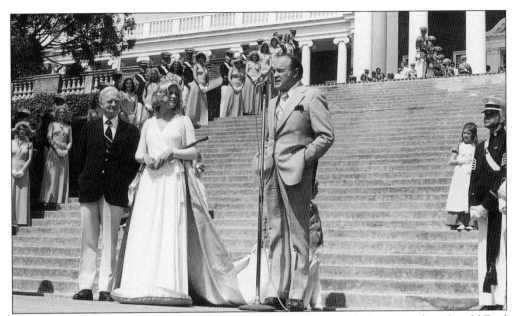

Bob Hope returned to serve as grand marshal of the parade in 1975 when President Gerald Ford crowned his daughter, Susan. The comedian is shown on the steps of Handley High School with Queen Shenandoah XLVIII and Senator Harry F. Byrd Jr. (Photograph by Mark L. Ainsworth; courtesy of the Handley Archives Collection.)

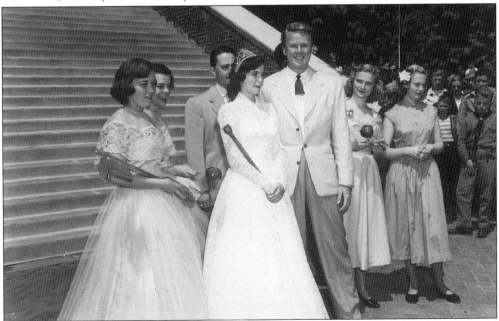

Queen Shenandoah XXIII, Anne Carleton Hadley, step-daughter of Vice President Alben W. Barkley, and other admiring young ladies join Van Johnson on the steps of Handley High School in 1950 when the popular movie star was parade grand marshal. On the movie star's right are Betsy Minegrode, Elizabeth Baker, and the queen. Shirley Long Marshall, who had just cut Johnson's tie, and Sally Pratt are on his left. Mayor M.B. Clowe can be seen behind the queen. (Photograph by Barr's Studio; courtesy of Bill Madigan.)

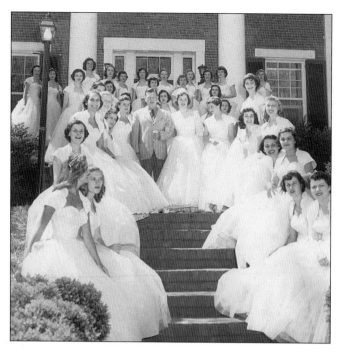

In 1953, Arthur Godfrey, who made his home in neighboring Loudoun County, was grand marshal. He is surrounded by members of the court and Queen Shenandoah XXVI, Katheryn Eisenhower, niece of President Eisenhower, on the steps of Macsfield, a private residence across from Handley School. Ann Arthur stands next to the queen, and Diana Hunt is on Godfrey's right. The popular radio and television star returned to the festival in 1962 when his daughter, Patricia Ann, was crowned Queen Shenandoah XXXV. (Photograph by Barr's Studio; courtesy of Bill Madigan.)

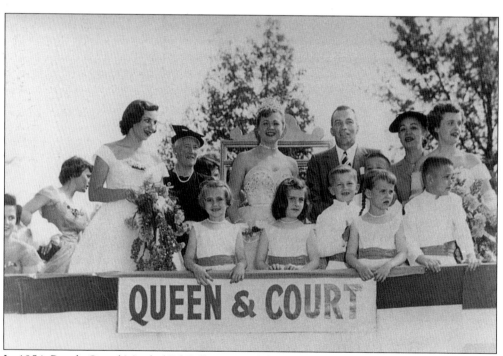

In 1954, Parade Grand Marshal Ed Sullivan stands between Queen Patricia Ann Priest and her mother, Ivy Baker Priest, treasurer of the United States during the Eisenhower Administration. On the Queen's right is Yolanda Walsh, a guest from Winchester, England. (Photograph by Barr's Studio; courtesy of Bill Madigan.)

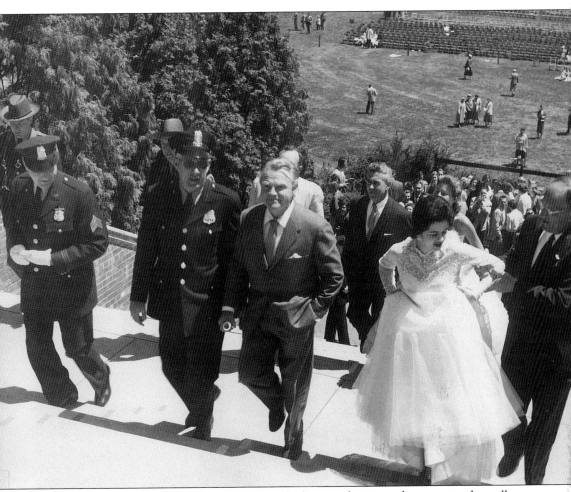

Jimmy Cagney, grand marshal of the 1957 parade, has an admiring police escort as he walks up the steps of Handley with Queen Shenandoah XXX, Anne Denise Doughty-Tichborne of Winchester, England. Claude Smalts, mayor of Winchester, Virginia, can be seen over Cagney's left shoulder. (Photograph by Barr's Studio; courtesy of Bill Madigan.)

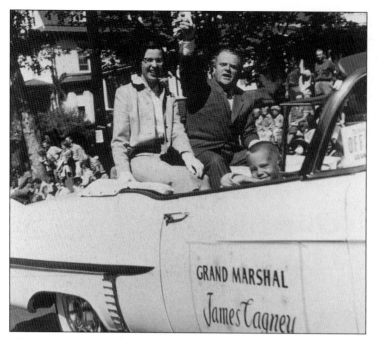

Grand Marshal Cagney enjoyed riding in the parade, but he told revelers at the Stag Luncheon how much he enjoyed the pageant. Cagney told the men he had never witnessed a more beautiful display, and he was particularly impressed that it was all done by amateurs. (Photograph by Barr's Studio; courtesy of Bill Madigan.)

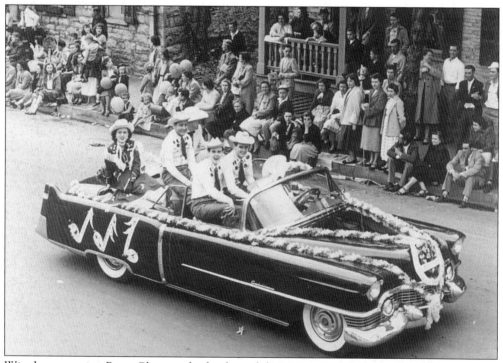

Winchester native Patsy Cline made the first of three appearances at the festival in 1955. In this photograph she is accompanied by members of the Peer Band, Grover Shroyer, Ray and Roy Deyton, Bill Peer, and the driver, Paul Deyton. (Photograph by Barr's Studio; courtesy of Bill Madigan.)

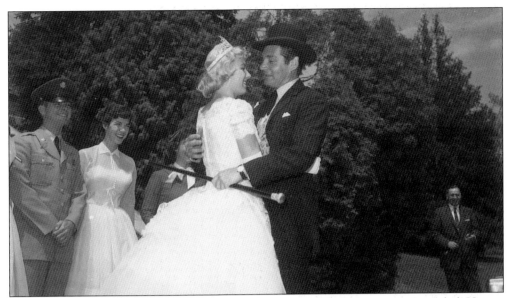

Movie and television star Gene Barry seems to be enjoying his duties as grand marshal. He was easily recognized dressed as Bat Masterson, the character he portrayed in a weekly television series. He is shown charming Queen Shenandoah XXXII, Sara Elaine Atwood, as her escort, Russ Tamblyn looks on. (Photograph by Barr's Studio; courtesy of Bill Madigan.)

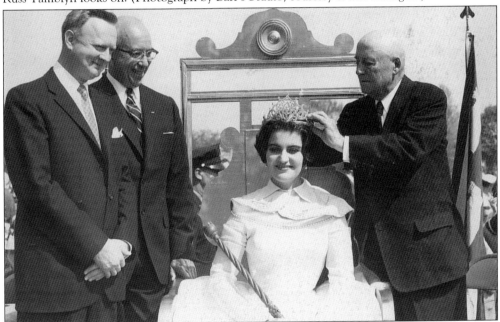

Sam Rayburn, a Democrat from Texas, served as Speaker of the United States House of Representatives for more years than any other person. He came to Winchester in 1958 to crown Queen Daphne Fairbanks, daughter of actor Douglas Fairbanks. Senator Harry F. Byrd Jr., on the left in this photograph, was responsible for bringing powerful politicians and other dignitaries to participate in the festival. Senator Byrd has been in all but two festivals since he served as a page to the first Queen Shenandoah in 1924. (Photograph by Barr's Studio; courtesy of Bill Madigan.)

In this 1975 photograph, Bob Hope is shown greeting Colonel Sanders, as festival president Mike Luby keeps an eye on things. Colonel Sanders returned the next year and again in 1977 for the 50th festival. (Photograph by Mark L. Ainsworth; courtesy of the Handley Archives Collection.)

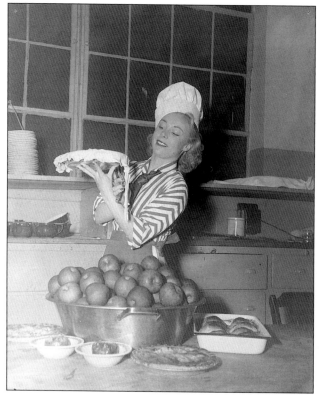

One thing all of the Shenandoah Apple Blossom Queens have observed is that they are made to feel like celebrities during their time in Winchester. Ice skating champion Gretchen Merrill proves that being a celebrity and queen of the festival can be a lot of fun. She is shown in the kitchen of the George Washington Hotel in 1948 as an honorary chef at the traditional apple pie-baking contest. (Photograph by Barr's Studio; courtesy of Bill Madigan.)

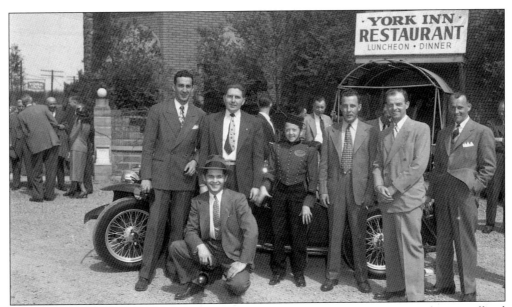

The celebrity who holds the record for attendance at the festival never served in an official capacity. Johnny Robentini, famous as a spokesman for the *Philip Morris Company*, was a celebrity guest the first time in 1949. By 1964, when he made his last appearance, the diminutive former bellboy had participated in six festivals. He is shown here in front of the York Inn with some of the friends he made in Winchester. (Photograph by Barr's Studio; courtesy of Bill Madigan.)

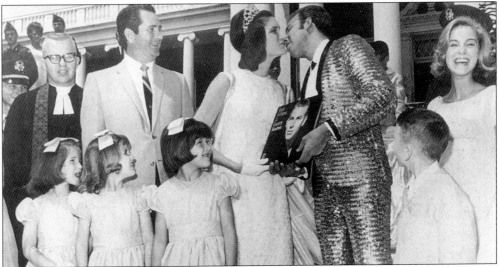

Another record is held by the family of President Lyndon Johnson. More members of his family have participated in the festival than any other non-local family. The President crowned his daughter, Luci, as queen in 1964, and she returned to ride in the 50th parade. Johnson's daughter, Linda, and his son-in-law, Charles "Chuck" Robb, have ridden in several parades when Robb served as governor of Virginia and as a United States senator. Two of their daughters, Lucinda and Jennifer, have served as queen. Luci Baines Johnson is shown receiving an album and a kiss from country music star Hank Williams Jr. in this 1964 photograph. (Unidentified photographer; courtesy of the Handley Archives Collection.)

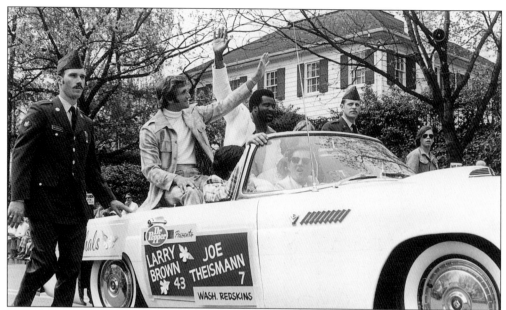

The addition of a sports marshal to the parade in 1966 proved to be very popular. Washington Redskins quarterback Sammy Baugh was the first, followed by Otto Graham, Fran Tarkenton, Dizzy Dean, and other sports heroes, who not only served as sports marshals but attended other festival events making themselves available to young and old fans. Two popular Washington Redskins, Larry Brown and Joe Theismann, are shown riding in the 1975 parade. (Photograph by Mark L. Ainsworth; courtesy of the Handley Archives Collection.)

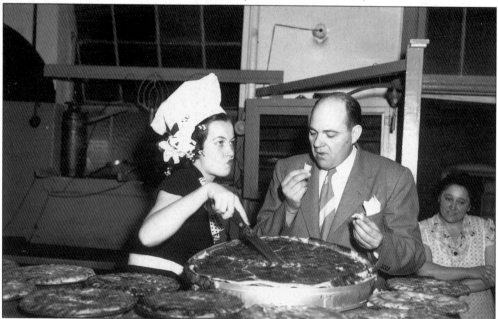

Tom Baldridge served as director general of the Shenandoah Apple Blossom Festival for 27 years, longer than any other person. While establishing that record, he seems to have enjoyed the festival events as this photograph of "Mr. B" partaking of the traditional apple pie indicates. (Photograph by Barr's Studio; courtesy of Bill Madigan.)

Seven

FIFTY YEARS AND GROWING

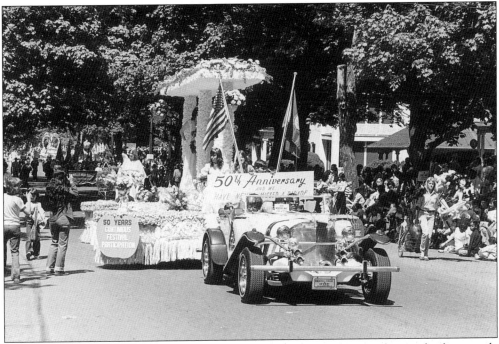

Elks Lodge 867 proudly proclaims continuous participation in the festival since the first parade in 1924 with this float pulled by a 1927 Mercedes driven by Ralph W. Poe. (Mrs. Clowser hired Mark L. Ainsworth as the photographer for the Shenandoah Apple Blossom Festival. All of the photographs in this chapter were taken by him. Mr. Ainsworth generously placed all of his negatives of festival events for the years 1974 to 1981 in the Handley Library Archives.)

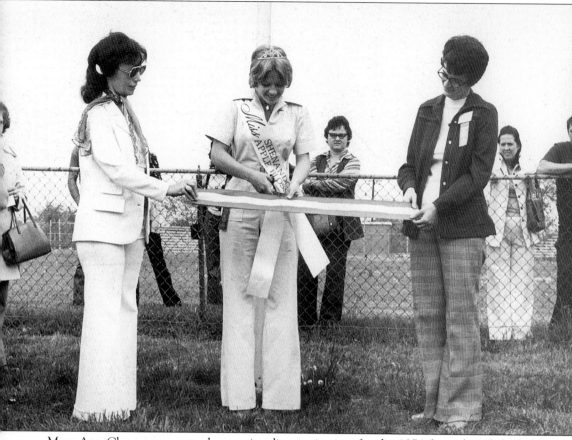

Mary Ann Clowser was named executive director in time for the 1974 festival, and she held that position until after the end of the 1980 festival. Mrs. Clowser joined the festival staff in 1952 and had undertaken planning, staging, and directing the pageant when Garland Quarles withdrew before the 1964 pageant. That was the year President Lyndon Johnson attended the festival and crowned his daughter, Luci. The first year Mrs. Clowser served as executive director, President Gerald Ford attended to crown his daughter as queen, and Bob Hope served as grand marshal. For Mrs. Clowser, staging the 50th anniversary festival was just another challenge. She made several marketing suggestions which the Board of Directors agreed to try. One of the ideas Mrs. Clowser brought to the festival was "Sunday in the Park," which has grown into a popular and profitable two-day craft fair. She is shown here holding the ribbon with Arline Maul (on the right) as Miss Shenandoah Apple Blossom opens the event for the first time in 1975.

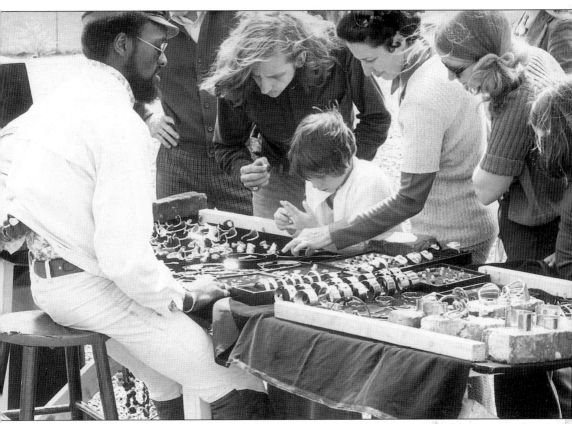

Some serious shoppers were captured by photographer Mark L. Ainsworth as they examined jewelry displayed in front of an unidentified vendor during the 1977 "Sunday in the Park."

Approximately 2,000 volunteers worked untold hours to make the festival's golden anniversary a success. Mrs. Frank Armstrong III and John Lewis served as co-chairman of the event. A special golden anniversary Lions Club float carried Mrs. Elizabeth Steck Arthur, the first Queen Shenandoah, and some members the 1924 court, including Harry F. Byrd Jr., J. Kenneth Robinson, Retha and Ethyl Cooper, and Lewis M. Hyde. Ted Morgan chaired the 1977 "Sunday in the Park" event, which had grown to include an antique car show, a beef Bar-B-Que provided by the Winchester Rotary Club, pony rides, and other entertainment. Thanks to the cooperation of the Winchester Recreation Department, huge crowds were also able to enjoy fire equipment demonstrations and a softball tournament.

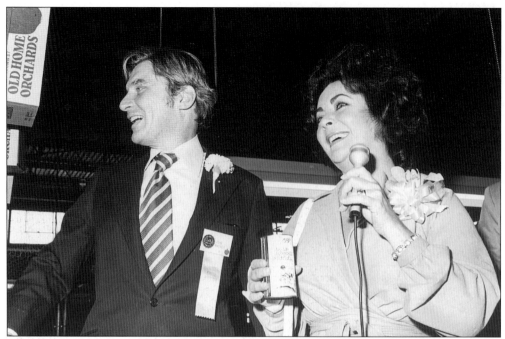

The coronation of the 50th Queen Shenandoah, Laury Boone, daughter of singer Pat Boone, had two ministers of crown. Elizabeth Taylor was married to Virginia senator John Warner, and they traveled to Winchester from their nearby farm for the festival. The couple shares a laugh at one of the events.

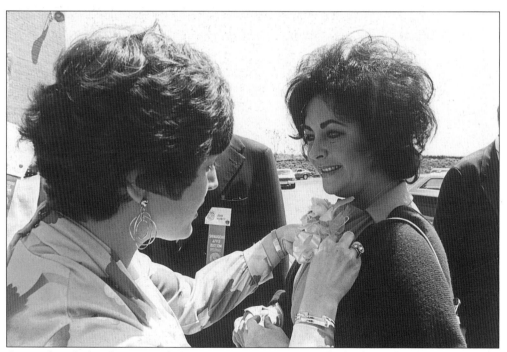

An unidentified volunteer is shown pinning a corsage on Elizabeth Taylor upon her arrival in Winchester.

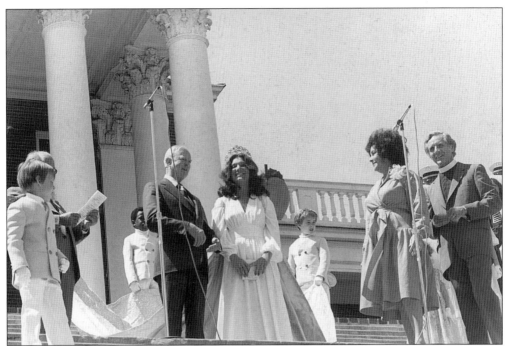

Miss Taylor joins Senator Byrd and Queen Shenandoah L on the steps of Handley High School, while, from left to right, Frank Armstrong IV, Duane Irvine Callis, Kevin Wayne Fox, and Reverend Robert W. Koons, pastor of Grace Lutheran Church, look on.

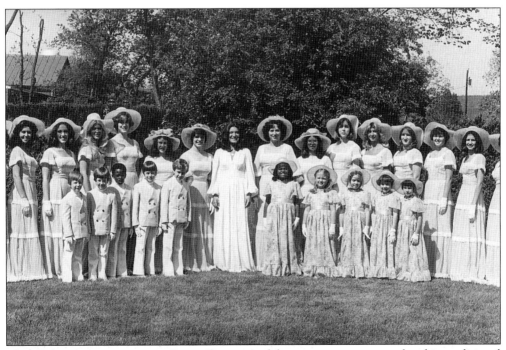

The 50th anniversary queen, Laury Boone, and her entire court pose for this traditional photograph.

The youngest members of the court are selected from families of volunteers who devote time and talent to the continuing success of the Shenandoah Apple Blossom Festival. Pages Travis Braxton Butler and Kevin Wayne Fox share a secret before the official business begins.

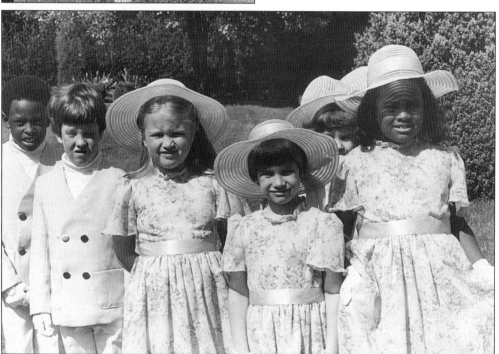

Little maids Stepheny Reney Gregory, Mary Katherine Potts, and Kimberly Dawn Reed pose with pages Duane Irvin Callis and Frank Armstrong IV for an informal photograph. Dana Courtney Byrd and Teresa Muse Bolliger also served as little maids during the 50th celebration.

This unidentified rider is too young to have participated in the first parade, but his bicycle certainly could have been used in 1924.

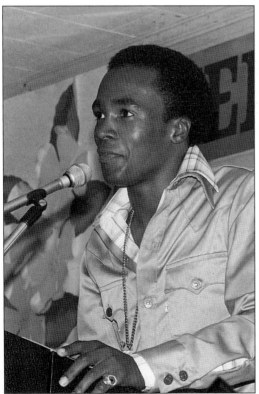

Sports celebrities, including Sonny Jurgensen of the Washington Redskins and Don Strock of the Miami Dolphins, came to Winchester for the 50th celebration. As with other celebrities, the sports figures are a popular draw, and they generously spend time with fans. Boxer Sugar Ray Leonard is shown addressing the Sports Breakfast in this photograph.

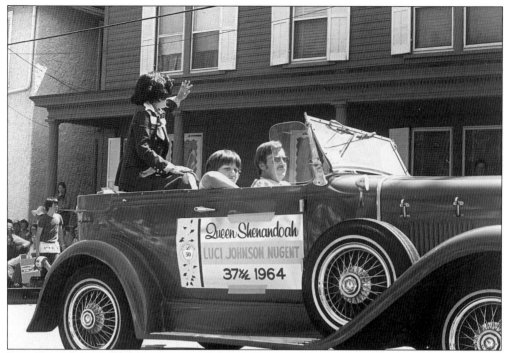

President Johnson's daughter returned to ride in the 50th parade. When Luci was crowned queen in 1964, members of the large press corps that accompanied her father disconnected some of the sound equipment. Fortunately, no such problems occurred in 1977.

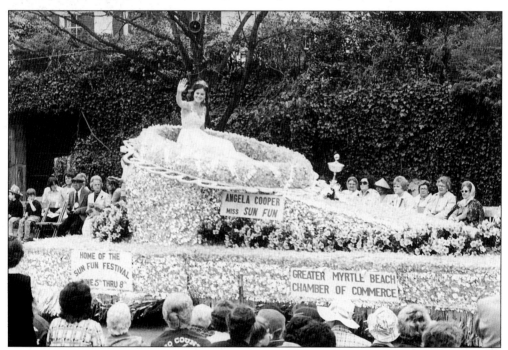

Myrtle Beach sent this float and Miss Sun Fun, Angela Cooper, to help Winchester celebrate and remind parade watchers of their festival in June.

The uniforms have changed considerably in 50 years, but the bands are always the crowd's favorite. Unfortunately, neither the band nor the majorette in this photograph could be identified.

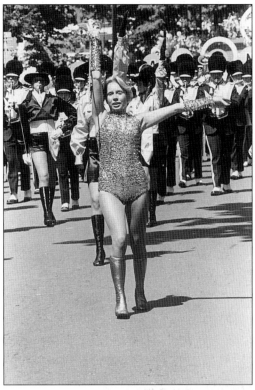

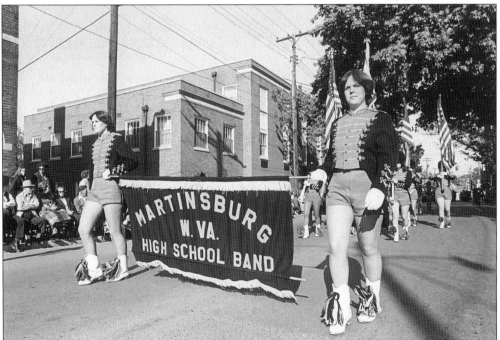

Martinsburg, West Virginia, a close neighbor of Winchester, has participated in the festival since its earliest years. The town was ably represented at the 50th festival by the high school band.

A parade, spectators, and vendors all celebrate 50 years of a great idea.